THEN & NOW

RUTHERFORD

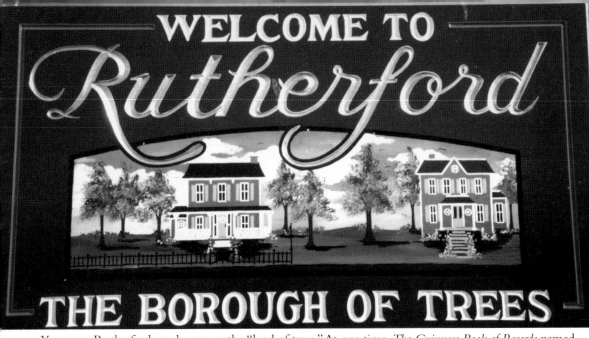

WELCOME TO Rutherford

THE BOROUGH OF TREES

Years ago, Rutherford was known as the "land of trees." At one time, *The Guinness Book of Records* named Rutherford as the most heavily treed land per acre in the metropolitan area. Pulitzer Prize winner William Carlos Williams immortalized Rutherford's trees in his poetry. In the late 19th century, most of Rutherford's residents lived on good-sized estates amid a profusion of beautiful trees. Newly macadamized roads were sheltered by these beautifully protective canopies. Washington Avenue, for example, was lined with rare maples and, at one time, the second-oldest elm in New Jersey stood on the present site of Willow Gardens Apartments on Union Avenue. One young man who had lived in Rutherford (1873–1950) wrote in his memoirs about playing in the woods in town under the mulberry trees, collecting chestnuts from the trees as well as carving initials in the old beech trees (some of which still exist today). The borough is still noted for its beautiful trees and has recently introduced new signage of recognition. Fortunately, the enterprising people who planned improvements at the time of the early development of the borough had the good judgment to allow the trees to be protected and spared. The early residents took such pride in their trees that the north end of Chestnut Street makes a sudden and awkward break because of two old maple trees that used to grow on the land about 40 feet apart. Because of the variety and quantity of trees, Rutherford still has a parklike atmosphere. Its charming homes are enhanced by red, white, and pin oaks; weeping beeches and willows; Canadian, Norway, and New England sugar maples; and the more recent additions of flowering pear and cherry trees. Rutherford's historic trees connect us to our past and invoke a sense of continuity and hope for the future.

Then & Now
RUTHERFORD

Lee Frances Brown

ARCADIA

First printed in 2002.

Published by Arcadia Publishing,
an imprint of Tempus Publishing, Inc.
2A Cumberland Street
Charleston, SC 29401

Printed in Great Britain.

Library of Congress Catalog Card Number: 2002106507

For all general information contact Arcadia Publishing at:
Telephone 843-853-2070
Fax 843-853-0044
E-Mail sales@arcadiapublishing.com
For customer service and orders:
Toll-Free 1-888-313-2665

Visit us on the internet at http://www.arcadiapublishing.com

*Dedicated to my parents, Agnes and Eldon Brown; my children, Tracy, Kimberlee,
and Joseph; my son-in-law Scott; my grandchildren Scottie and Shannon; and the people of
Rutherford's yesterdays who each in their own way helped create Rutherford and those
who seek to preserve it for the tomorrows to come. Let this be a touchstone for community pride.*

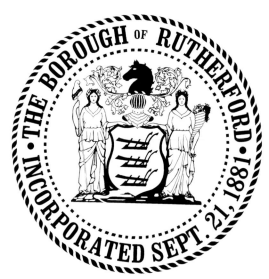

The borough of Rutherford seal shows the incorporation date of September 21, 1881, with symbolism of th
town's origins.

CONTENTS

ACKNOWLEDGEMENTS

I would like to thank all of the people of Rutherford who took the time and interest to assist me in gathering together images of the town from days of yore. Special thanks go to those individuals who inspired encouraged, and supported me throughout this endeavor. The book could not have been completed without the expertise of Robert Clifton, who photographed the majority of the "now" images in this book. Thanks also go to Robert Clifton Jr., Rutherford High School teacher Al Weber, Rutherford High School student Dan Pinedo and my former classmates David Goodhart and Malvern Burroughs. I also appreciate the assistance of An Romano, Janet Strom, Pat Marillo Garbe, John Daub, Peter and Jean Marshall, and Helen Matthies.

Thanks go to my mentors John Dollar, professor emeritus at Fairleigh Dickinson University, and his wife Muriel Dollar, Ed.D. In particular, I would like to thank Virginia Marass, who graciously offered her collection and expertise on Rutherford. Space does not permit mentioning everyone who contributed, but again m sincere thanks go to the people of Rutherford for their continued encouragement and support. Of necessity choices had to be made for this book in order to present an overview of Rutherford's "personality" while pointing out some of the town's lesser-known treasures.

Many sections rely on unpublished materials located in the Bergen County Department of Parks DC & HA Information was also taken from *The Historic Sites Survey for the Borough of Rutherford*. Other resources includ *The Architecture of Bergen County, New Jersey*, by T.R. Brown and S. Warmflash; *Atlas of Bergen County*; and Fairleigh Dickinson University with the gracious assistance of Maria L. Kocylowski, New Jersey Documents librarian.

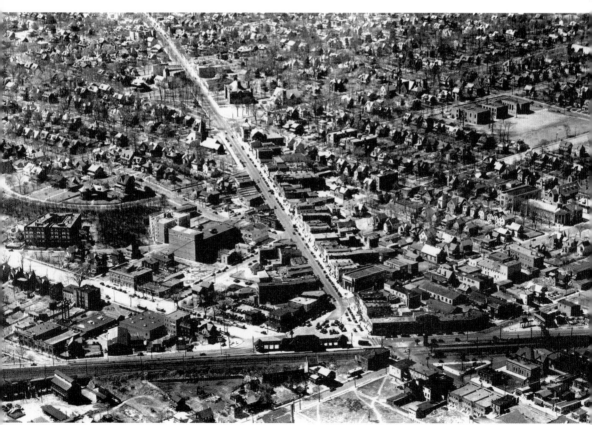

This aerial view of Rutherford shows the Erie Railroad (east and west) and Park Avenue (north and south).

INTRODUCTION

Rutherford was once a part of the Atlantic Ocean. Shells and skeletons of fish have been found in the earth as evidence. Stone arrowheads have also been discovered because, over time, the sea receded and the Lenni Lenape Indians arrived and made this land their home. Eventually, Europeans also came to America. In 1609, Henry Hudson, representing the Dutch East India Company, explored the area. Then, other Dutchmen came, having received patroonships to settle in this country. Some land in the area was purchased from the Native Americans for 140 fathoms of black wampum, 19 watch coats, 16 guns, 60 double hands of powder, 10 pairs of breeches, 60 knives, 67 bars of lead, 1 tanker of brandy, 3 half vats of beer, 11 blankets, 30 axes, and 20 hoes. Originally, this land was tree-covered woodland and cedar swamp with many waterways (such as the Passaic and Hackensack Rivers). In 1664, the Dutch director general, Peter Stuyvesant, surrendered New Netherlands (the territory included in a commercial grant by the government of Holland to the Dutch East India Company in 1621) to England, which in turn was divided into the two colonies of New York and New Jersey. The split was further divided by the Quintipartite Deed of 1676, which divided the province into East and West Jersey. (In June 1776, the provincial congress adopted a constitution and declared New Jersey a state.)

Therefore, the English became an important influence on the area's history. Charles II of England granted this New Netherland to his brother, James, Duke of York. James, in turn, granted proprietorship of the lands between the Hudson (at latitude 41 degrees north and the northernmost part of the Delaware) to Lord John Berkeley and Sir George Carteret for their service. In 1676, Carteret sold a tract of this land to Capt. William Sandford on behalf of Maj. Nathaniel Kingsland of Barbadoes, West Indies. (This area became known as New Barbados Neck.) In 1680, Capt. John Berry, also from Barbados, secured 10,000 acres of land adjoining the Kingsland property and called it New Barbados. Modern Rutherford covers areas of both the Kingsland (New Barbados Neck) and the Berry land (New Barbados). Union Avenue is approximately the dividing line between the two patents. Kingsland sold land to Bartholomew Feurt and Elias Boudinet. Berry sold his land to Walling Jacobs Van Winkle, Garret Van Vorst, and Margaret Stagg. Later, the lands were further divided and sold to the Kips, Ackermans, Van Nostrands, and Bantas, among others. These families farmed the land, for their livelihood was mainly market gardening in those times. From 1692 until 1825, this area was known as New Barbados Township. In the 19th century, Rutherford was included in a changing series of counties and townships. Ultimately, for practical reasons based on long and difficult traveling experiences for the local people, a separate area called Union Township was formed in 1852 and became a part of Bergen County.

The real growth of Rutherford (Boiling Spring) received its impetus from a group of wealthy New York businessmen who saw the resort advantages of the Rutherfurd Park Hotel (formerly John Rutherfurd's Edgarston Manor). The Valley Brook Race Course was built and, with the attractive accommodations of the Rutherfurd Park Hotel, that section of Union Township became an extremely popular resort. New Yorkers, seeing the residential potential of that area, bought property and formed a land company known as the Rutherford Park Association. Other land companies followed. The prominent hotel and racecourse influenced the Erie Railroad officials to rename the station at Boiling Spring to Rutherfurd Park in 1866. (The original name for the area at the northwestern end of Union Township was Boiling Spring, named for a large cold-water spring where, in 1832, the New York and Paterson Railroad established a station.) Through the 1860s, various land associations continued to acquire property and plotted lots and avenues. The name Rutherfurd (Rutherford) Park was given to the emerging town in 1870. In 1875, the *Park* was dropped from Rutherford's name, having been voted unnecessary.

In 1881, the town of Rutherford was incorporated. The petitioners for the incorporation were Edward W. Dean, George Hollister, Thomas Love, S.W. Hollister, Benjamin Yates, Robert Burgess, Thomas Daniel, Alfred Oakley, William H. Stevens Jr., Henry V. Gilbert, Edward J. Love, I.S. King, Mary T. Shafer, Thomas H. Craig, Charles Meyers, Thomas H. Unckles, Samuel L. Harris, Charles E. Parker, Henry Koster, D.B. Ivision, H.G. Bell, E.N. Bell, William Ogden, John Hooper, G.I. Know, A.P. Williams, M.A. Allison, and W.H. Nevins. (It is of interest that the area had a population of some 3,000 then, and Rutherford's current population is about 18,000.) Today, Rutherford still maintains its small-town atmosphere, and its location provides its residents access to all of the convenience of the cosmopolitan social, economic, and cultural advantages of New York

City. It is a lovely tree-lined town of many beautiful Victorian homes. It is near Newark and Teterboro Airports. It is serviced by the New Jersey Transit train line and the soon-to-be-completed Secaucus Transfer Station, which will link the Bergen County train lines to the Amtrak Boston-Washington line. Commuters from the town of Rutherford will also be able to go directly by train to midtown Manhattan in a matter of minutes. Visiting commuters stopping at Rutherford's 19th-century train station at the end of Park Avenue by Station Square (earlier known as Depot Square) can also see that Rutherfordians are continually improving their downtown district and maintaining their "sense of place" with a desirable atmosphere of excellent restaurants and pleasurable shopping experiences in a quaint, safe environment with all of the modern benefits of today. Ultimately, what makes Rutherford special is the respect its residents have for the past while they carefully incorporate the advantages of present innovations to move forward into the 21st century.

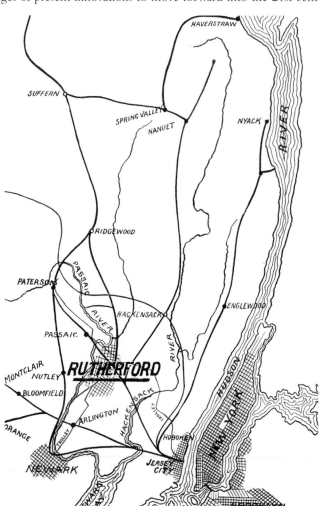

This 1871 map shows the town before it was called Rutherford. It shows the relationship of the town to the greater New York area. In the early 19th century, when Alexander Hamilton passed through Rutherford, he saw the meadowlands and its cedar trees intersected by minor streams. He crossed the Hackensack River and Berry's Creek on his way to Paterson and found himself in a beautiful region of orchards and farms. He considered it a favored territory lying between the Passaic and Hackensack Rivers. The region, prior to this map, was the market garden for New York for more than 150 years. Rutherford is now an established suburban commuter town with convenient proximity to New York City. The traveler on the Erie Railroad is struck by the admirable location of Rutherford, which has kept pace with the needs of its citizens in relationship to its location.

In 1862, the first map suggesting streets and avenues was published, and several wealthy businessmen from the city built homes in town. Most of the numerous roads, which crosshatch current Rutherford, are comparatively recent, but three of the present roads go back two centuries or even more. The oldest road in Rutherford is Union Avenue. Riverside Avenue dates back to 1716. The last surviving old road is Meadow Road, built in 1794. Park Avenue was created in 1866. The first streets after Park Avenue were Erie Avenue from Union to Meadow Road in 1867, Alpine Span (Ridge Road) in 1868, and Orient Way in 1872. Rutherford Avenue was also completed in 1872 as well as the Rutherford Avenue Bridge. In 1875,

Chapter 1

ROADS OF

RUTHERFORD

Montross Avenue was opened, and then roads developed rapidly. The Mount Rutherford Company, one of the early real estate groups, made this map in 1871. (Courtesy Peter Van Winkle.)

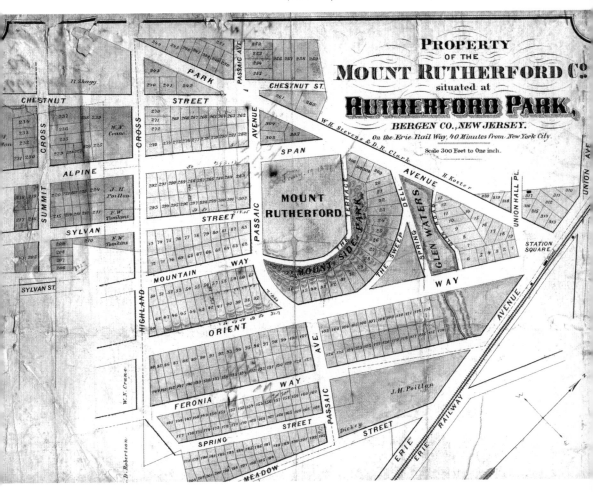

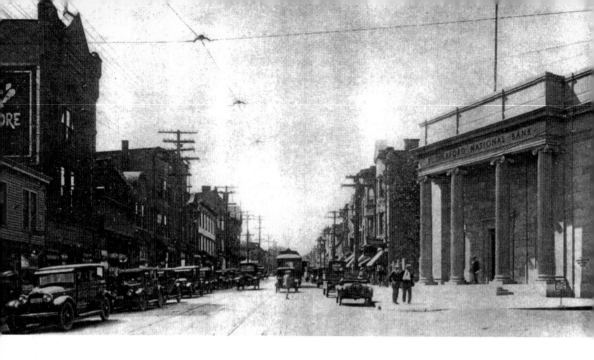

P ark Avenue, the main thoroughfare of Rutherford, was created in 1866 by the Rutherford Park Association as a direct route to its development on the Passaic River between Rutherford Avenue and the Valley Brook Race Course. Prior to its construction, people arrived at the Boiling Spring train station and were driven by carriages over Boiling Springs Lane (Union Avenue) to the Rutherfurd Park Hotel on River Road. (The Rutherfurd Park Hotel was previously called Edgarston and was John Rutherfurd's home, the gentleman after whom the town of Rutherford was eventually named.) It was a circuitous route over poor, narrow dirt roads. Within one year of Park Avenue being constructed, six land companies had been incorporated, and the area was evolving into a true town. The trolley car tracks in the 1920 photograph are still there under the macadam. The Rutherford National Bank is now the Bank of New York.

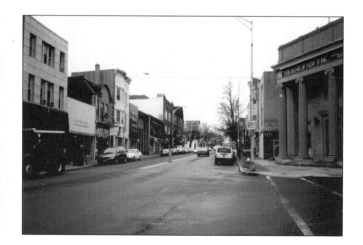

Rutherford's post office (built after 1897) was next to the Turner Building (built in 1895) on Park Avenue, as shown in this early-1900s photograph. (The first post office was a small wooden structure on the southwest corner of Orient Way and Spring Dell.) It is interesting to note the dirt road and the horse and buggy of 100 years ago and to consider what mode of transportation will be here 100 years from today. In the present-day photograph, pride in Rutherford's main thoroughfare is apparent with the recently installed streetlights, brick and concrete pavers, and flowering pear trees. (The horse and buggy is standing in the same location as the streetlight in the foreground.) Although this view does not show the facades of these vernacular Renaissance buildings, the original structures are still in commercial use on Park Avenue. (Below courtesy Virginia Marass.)

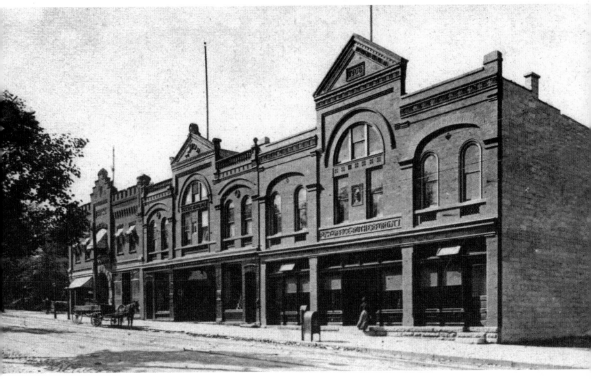

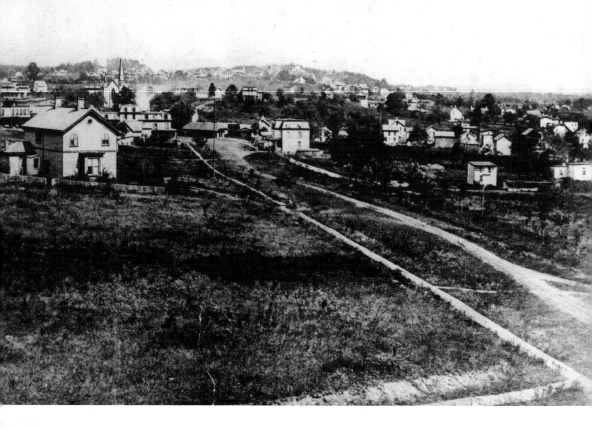

Orient Way was built in 1872 and was to become the main street of the borough. In the 19th century, however, there was a racecourse in a direct line with Park Avenue. The merchants took advantage of that, and Park Avenue thus evolved as the main shopping area. In 1924, Orient Way had a little macadam in the middle and dirt on the sides. Automobiles were creating dust problems. Harold Allen—a member of the Michigan State Highway Commission when automobiles started to become popular in Detroit, along with the start of concrete roads—knew exactly how to construct a paved road of this magnitude. With the help of Griswold Holman, an ordinance was passed and road construction began. In the 1872 photograph, the home to the left is 64 Orient Way, birthplace of Edward S. Brown, a noted insurance agent. This is now the location of an apartment building.

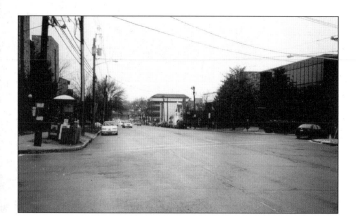

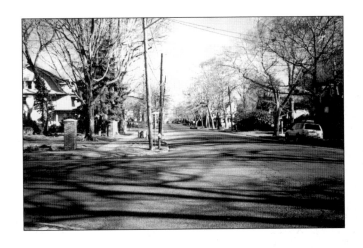

Ridge Road (formerly known as Alpine Span) existed in 1868. It was graded in 1872–1874 by an act of legislature. Ridge Road branches from the main thoroughfare of Park Avenue to run southeast, leading to Lyndhurst. It is a broad avenue lined with old trees, and the district is considered one of the finest residential sections in Rutherford and worthy of state recognition as a historical district. The homes are mostly frame structures, with a few of brick or stucco. Many are outstanding for historical or architectural reasons. The architecture ranges from before 1876 to 1931. These photographs show the corner of Ridge Road and Addison Avenue. Note the mode of transportation in the older photograph (1923). (Below courtesy Virginia Marass.)

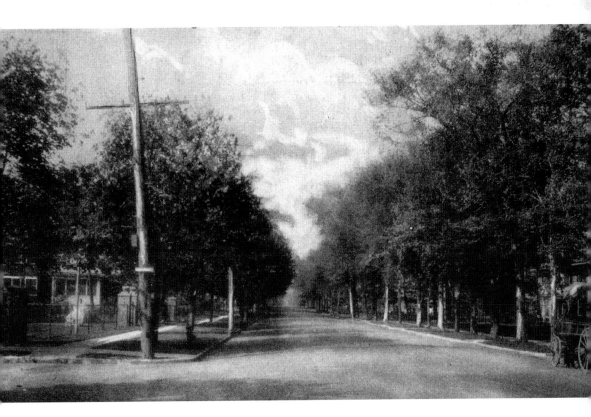

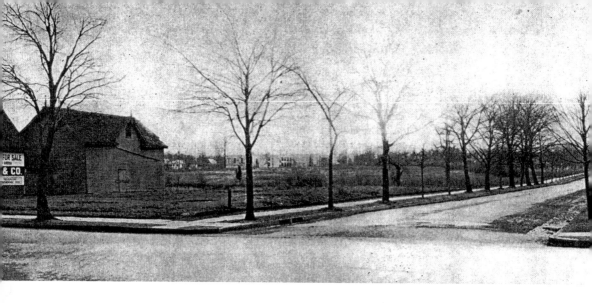

Union Avenue, the oldest road in Rutherford, was known as Boiling Springs Lane because of the rushing springs nearby. The original "Old Indian Trail" ran from the spring down the same route it takes today to Montross Avenue, where it circled toward the river. The Lenni Lenape Indians crossed the Passaic River near Pierrepont Avenue by a reef *c.* 1671. They made a trail to the Boiling Spring (near Station Square). In 1764, Boiling Springs Lane (Union Avenue) was a road. Even in 1861, however, Union Avenue was still a sandy narrow lane. By 1866, after Park Avenue was established, improvements came rapidly. In the 1924 view of Union Avenue near Wood Street, portions of the Kip farm can be seen with a For Sale sign by Van Winkle & Company. In the distance is Rutherford High School. Today, the high school is obscured by the Abbington Apartments.

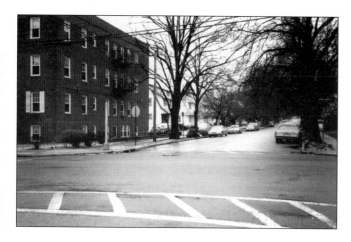

In this 1924 view of Union and Montross Avenues, the Tiegler farm is to the left. The Tiegler house dates from 1862, when Floyd W. Tomkins conveyed the property at the corner of Boiling Springs Lane and Willow Avenue (now known as Union and Montross Avenues) to David B. Ivison. In 1892, Mary A. Tiegler bought the house and lived there until 1946, when the Willow Gardens Apartments replaced it. At the left corner, the columns on the porch of the Peter Kip farmhouse can be seen. In 1682, the Kip farmland belonged to Capt. John Berry's daughter. She sold it to Garrett Van Vorst, whose sons conveyed it to Peter Kip. His grandson, Peter Kip lived there from 1842 until 1920. The house was torn down in 1950. The present-day photograph shows the Willow Gardens Apartments today, and note that the Kip house is gone.

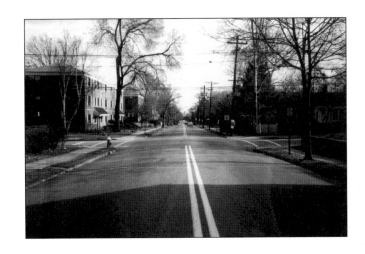

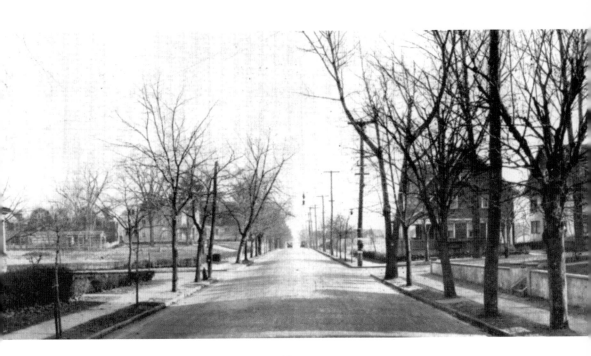

62151

R iverside Avenue dates from 1716, when a narrow road was built from Jacob Van Winkle's property to the border of the Van Ostrand property. In the beginning, this road followed the river past Union and the Erie Railroad line to the Paterson Plank Road, which was then the main stagecoach route to Paterson from Jersey City. (It was a toll road, and the farmers of the area preferred to send their goods down the Passaic or Hackensack Rivers to Newark.) Later, the road along the river was rerouted to leave the river at West Passaic Avenue and follow what is Jackson Avenue today. The very first farmhouse in Rutherford (Capt. John Berry's) was located on the old River Road, near Hastings Avenue. Until only a few years ago, the foundation of this home could be seen. Today, apartment buildings cover the site.

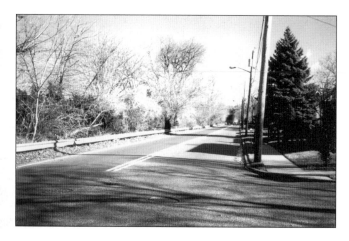

Rutherford has a rich and diverse architectural history. Originally, the area was farmland with a few old Dutch-American stone houses. Architects in the 19th century developed picturesque buildings and homes for the wealthy businessmen coming out to the "country." Rutherford is distinctive in the fact that it has gracefully combined the old and the new, giving the townspeople a sense of place by maintaining its continuity. It has a castle, Arts and Crafts cottages, and many styles of homes telling the story of small-town America's history in a nutshell. If you look closely at the architectural detail in this picture by renowned photographer Fred Stettner, you will recognize the Ionic column on the Bank of New York on Park Avenue, one of Rutherford's notable buildings. Ionic columns were often chosen as symbols of trustworthiness and permanence, certainly a fitting choice for a banking institution.

Chapter 2

DISTINCTIVE

BUILDINGS

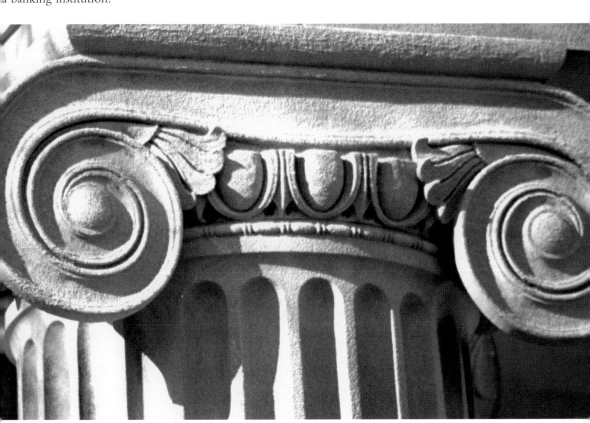

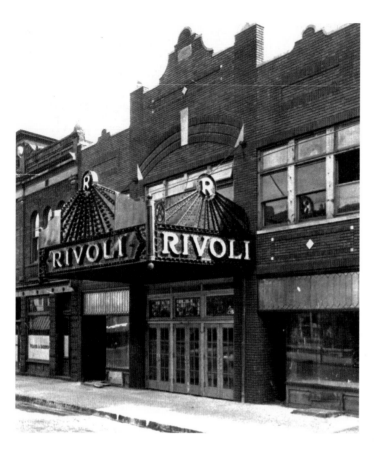

Rutherford has always had many cultural activities and organizations. For example, the Rutherford Vaudeville Club first performed at the opening of the Ames Avenue Lyceum on October 1, 1894. The Rutherford Opera Company (known as Our Own) flourished until World War I, performing at the Lyceum Hall on Ames Avenue and later at the borough hall in the old armory building. Gilbert and Sullivan operettas were featured, and they packed the house at each performance. The Rivoli Theatre, which was located at 7–11 Sylvan Street, was constructed in 1921 as a vaudeville house, later becoming better known as a theater for big bands and for silent and then sound films. It is admired for its spacious interior, good acoustics, and spectacular crystal chandelier. The theater was damaged by fire in 1977 and was later converted into the William Carlos Williams Center for the Performing Arts

(which opened in 1982), where movies and theatrical performances are held. (Courtesy William Carlos Williams Center for the Performing Arts.)

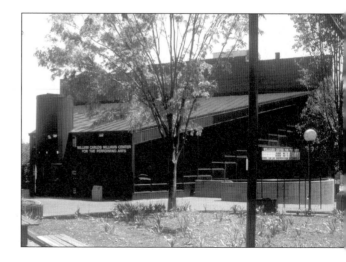

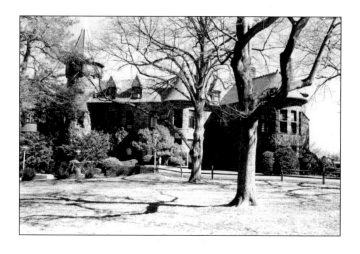

Rutherford has Iviswold, dating back to 1869. The castle has been an elegant manor, a social club, a movie set (*The Three Musketeers* was filmed here, as well as *In Again, Out Again,* in which Douglas Fairbanks Sr. climbed up buildings and into the sewers of Rutherford), and part of two colleges. In 1858, Lloyd Tomkins purchased land and built Hill House. In 1887, the next owner was wealthy David Ivison (president of the American Book Company), who built Iviswold on the foundation of Hill House. The castle was sold several more times. During one transaction, an interesting condition was attached to the sale: "Never permit to be erected upon said premises any brewery, distillery, slaughterhouse, brass foundry, nail factory, soap, nor any tenement house." In 1906, the Schatzkins family bought Iviswold, renaming it Elliott Manor. The Union Club bought Elliott Manor in 1925 for a social clubhouse, but the Great Depression came and the Rutherford National Bank held it until 1942, when it became Fairleigh Dickinson Junior College (now Fairleigh Dickinson University). It is currently part of Felician College.

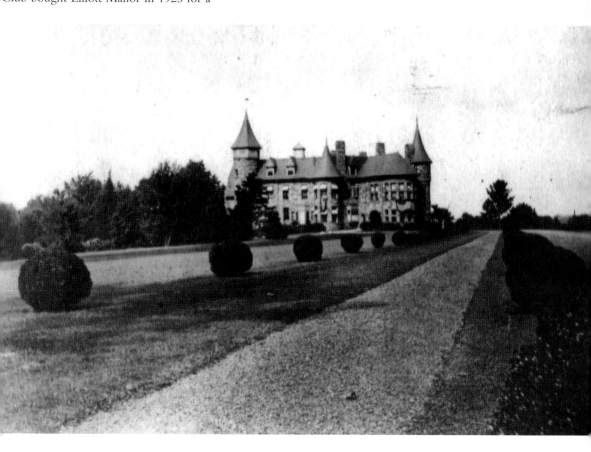

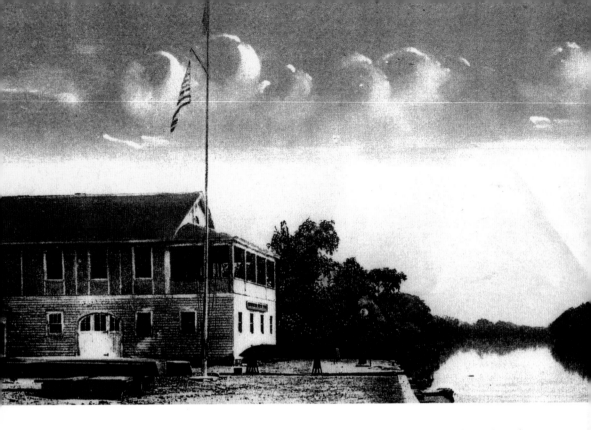

This building on River Road was originally the site of a boat club incorporated after the end of the Civil War. Vacant for some time and in disrepair, the structure was noticed by rowing enthusiasts, who leased it from Rutherford. This group, the Nereid Boat Club (founded in 1868 in Belleville) is an extremely active group. It has more than 150 members, and head coach Ted Bonanno trained the India Olympic team here on the Passaic River. Improvements are constantly being made, and rowers actively compete in regattas in New Jersey and other states. The boathouse is on a site where there are plans for a public park. (Of interest is the historically significant wrought-iron fence, which is soon to be installed. It originally guarded the entrances to the boathouses that once lined the Harlem River on New York's historic Boathouse Row.) The photographs show the original boathouse and the restoration.

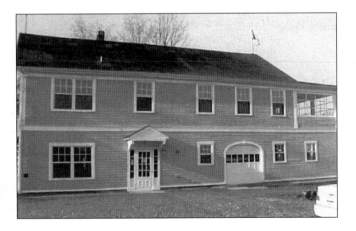

The original A. W. Van Winkle structure was built in 1866. The current photograph shows its replacement. (At one time, a living spring of cold water was located in the cellar.) A resident who wrote about Rutherford in 1898 said, "In the 1860s, several citizens feeling Rutherford offered many advantages as a residence to city business men, united with some New Yorkers in forming a land company, The Mount Rutherfurd Company, and purchased one hundred acres of upland from Mr. Daniel Van Winkle for one thousand dollars per acre. This sale gave great impetus to real estate operations for miles around Rutherford." Floyd Tomkins, the first real estate agent, tried for years to interest New Yorkers in this town as a vacation spot. However, it was not until the

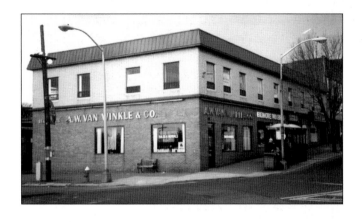

Rutherford Park Association promoted the Rutherfurd Park Hotel and the racecourse that people saw the advantage of living here.

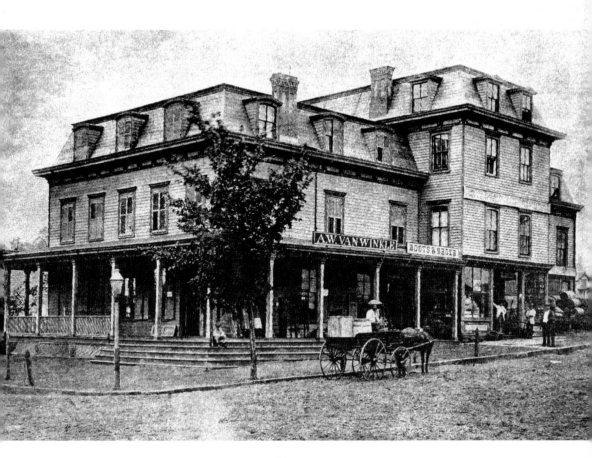

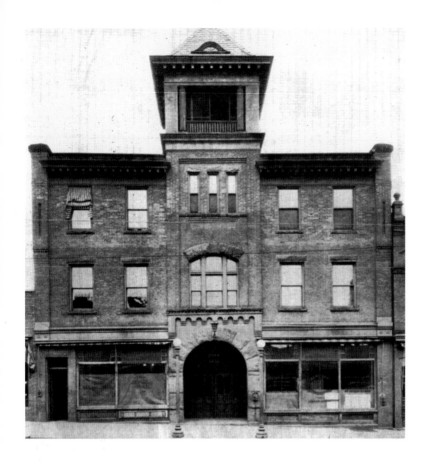

The National Guard Armory was built
c. 1895 for Company L, 2nd
Regiment, National Guard of New Jersey.
Rutherford has reason to feel proud of its
Company L, as they carried away many
laurels. These men also volunteered
during the Spanish-American War. The
original officers of Company L consisted
of Capt. Addison Ely, Lt. Wilkin
Bookstaver and Lt. J.J. Blake. The armory
was used as Company L Rifle Association
for a time. It was purchased by the
borough in 1900 and became city hall. (In
1912, William Howard Taft spoke there.)
Also, the Rutherford Opera Company,
known as Our Own, performed at the
old armory building. From 1900 until
World War I, Rutherford showed progress
but remained a country town. Its
suburban houses and farmlands made an
attractive home community. The armory
building still exists but is now Mandee's, a
women's retail clothing store.

The Turner Building was constructed in 1895. This building is located at 86–88 Park Avenue. Near the top of the building today is still a broad ribbon reading, "1895." At the angles are scrolled acroteria. Above the flat-headed windows is a frieze of a classic decoration, and Ionic capitals surmount the pilasters. The Turner Building was named for Mayor E.J. Turner (his monogram appears on a medallion centered on the facade), who ran a grocery store at this location from 1895 to 1905. This building, which has some alterations, still reflects the taste for Renaissance composition and detail popular in the 1890s. Little Treasures and Sara's Children's Boutique now occupy the building.

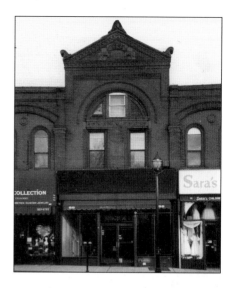

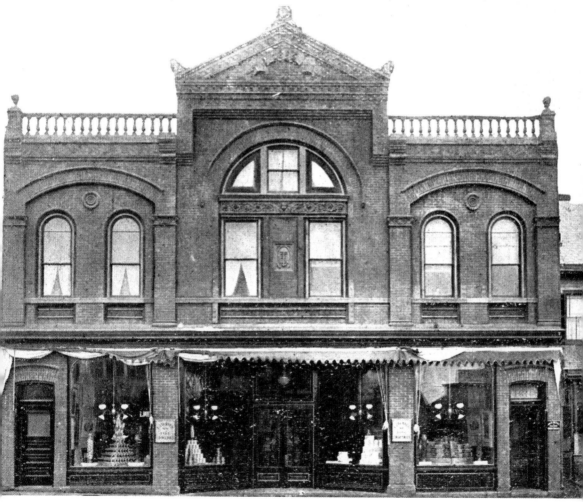

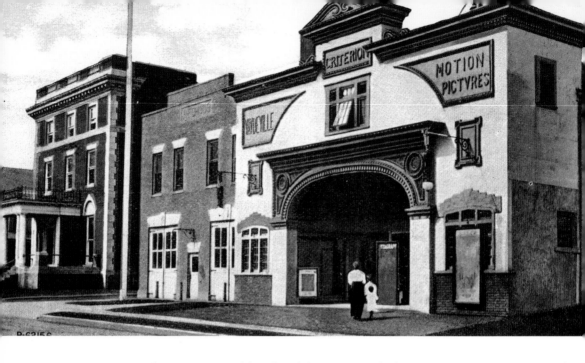

The cornerstone of the Elks Club building was laid on February 22, 1908. It is typical of many early-20th-century public structures that used Colonial and Renaissance symmetry and design features, often applied as here to the facade of an otherwise plain structure. It is freestanding in an area of mixed types of buildings. The doorway has a leaded transom and sidelights. The original building was extended at the back. The early-1900s photograph shows the Criterion Theater, which was opened in 1912 and flourished until it faced competition from the Rivoli Theatre, which was opened in 1921. It is now the location of Engine Company No. 4, which was originally organized as the Rutherford Hose Company in 1896. This company is now housed with Company No. 1. The Rutherford First Aid Ambulance Corps is housed where the original Ames Avenue fire station was located. (Above courtesy Bob Giangeruso.)

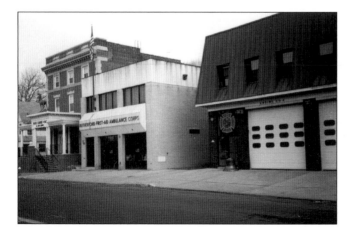

The building at 38 Park Avenue was originally the home of the William Black & Company hardware store. Advertisements for the store read, "Look out Yourself for the Hardware and you will have cause to be proud of your new home. Possibly it is because the cost of the Hardware cuts so small a figure in the total cost of the house that its selection is so often neglected, and the fact is overlooked that, for the dollars spent, nothing adds so much to the appearance of a dwelling as well selected Hardware. Our Furniture Department is filled with a selection of fine goods at prices which

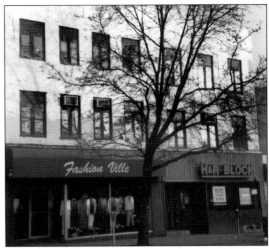

make it economical to deal here. Our staples include a large assortment of useful and fancy crockery and glassware, a varied collection of the famous Miller Lamps, and everything which a first-class, up-to-date hardware store should handle." Today, this altered building houses the Fashion Villa and H & R Block.

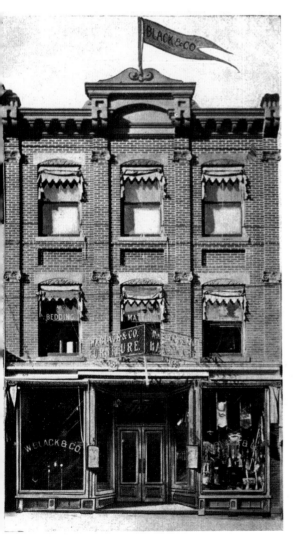

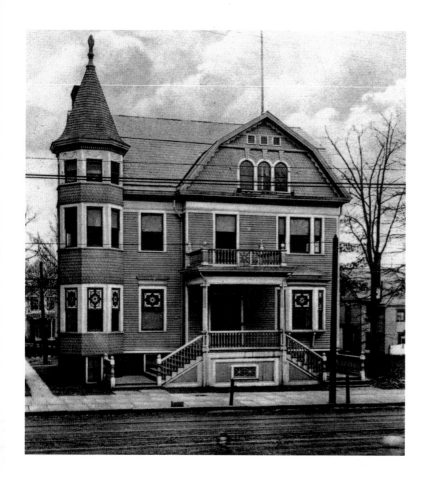

The Union Club building was built in 1896 next to the original Presbyterian church. Later, it became the Presbyterian parish house. (The original Presbyterian church building was constructed in 1869. In 1896, David B. Ivison presented it to the Library Association started by the Woman's Reading Club to be used as a library.) Both buildings no longer exist. A new library was built on the site of the old Presbyterian church-library in 1958, and a sunken garden is next to this library where the Union Club building once stood. The history of this club is quite interesting. Its evolution began with the Rutherford Wheelmen, a bicycle club. In 1889, they joined forces with the Rutherford Chess Club to form the Rutherford Field Club. Eventually, it evolved into a social club (the Union Club), and they built a new clubhouse on Park Avenue. The building housed a restaurant, bowling alleys, and bachelors' lodgings. One Rutherfordian remembers he had a great job of setting up pins there.

Historically, this is an important structure. Restaurateur Robert Wong has beautifully restored it. In Walker's 1876 map, it is Stewart's Hotel and, in 1892, it is shown with a mansard roof and a bracketed cornice. In 1887, it was E.J. Turner's grocery store. In 1895, W.P. Kestrel had a seed store here and, in 1899, William McMains owned the building. It also served the Congregational church at one time, and upstairs was the Rutherford Secretarial School in the 1950s. Another use was as the Rutherford Drug Store. This store also had old-fashioned stools at the counter where you could sit and have one of the store's famous milk shakes. Seen in front of Mignon's Restaurant in the 2002 photograph are R. Scottie Mackie (Rutherford Emergency Medical Service), Andrew Bertone (former

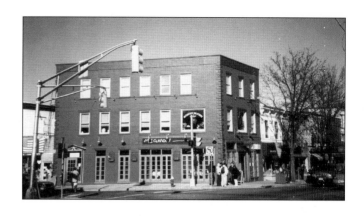

mayor), John Daub (planning board member), Richard Allen (Downtown New Jersey trustee), and Ed Ryan (Rutherford Downtown Partnership).

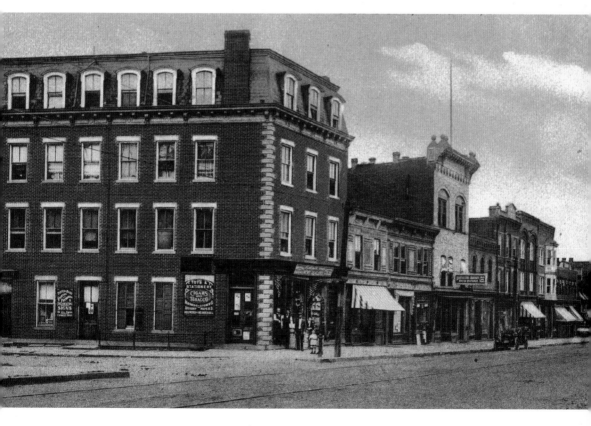

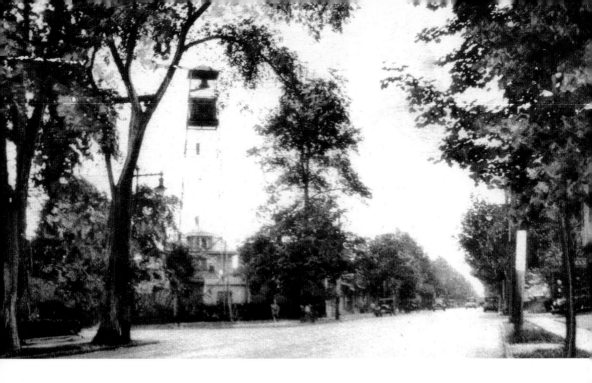

Prior to recent innovations regarding fire alarms, there existed a fire bell tower where the Firemen's Memorial is now located on Park Avenue near West Pierrepont. When the tower was taken down in the 1940s, the bell remained on this site for a number of years. Eventually, it was moved to Ames Avenue, where it was placed in front of the firehouse there. Before an alarm system was installed with the opening of Company No. 2's old firehouse on Park Avenue in 1913, the department relied on a fire bell in the belfry of the old public library building, which was the original Presbyterian church. (Above courtesy Virginia Marass.)

In 1936, a young man named Ralph Sifford arrived in Rutherford from North Carolina. Sifford began to manage the Esso gas station on Park Avenue and Park Place. When he assumed operation in 1945, employees were hard to find. His son started to help in the station. Later, sons Ralph and Leon worked there also. Their philosophy was "We never say no!" Great service was the key to their success. The business of cars became the future for the Sifford men in both New Jersey and Florida. (This family remembers well the history of Rutherford. Wiley remembers that during World War II, his mother would send him to the A & P with food ration stamps to purchase sugar, butter, flour, and other staples. A line of people wrapped around Donaldson Avenue, waiting to obtain these scarce items.) Today, a gas station is still at this location called Park Sunoco, owned and operated for 25 years by Mike Latorraca, a Rutherford resident.

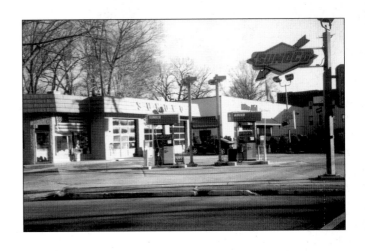

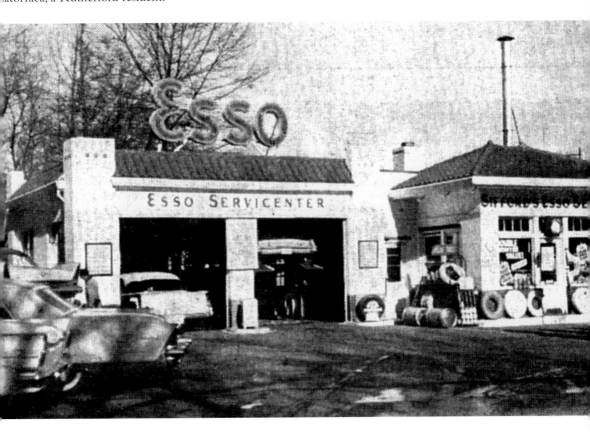

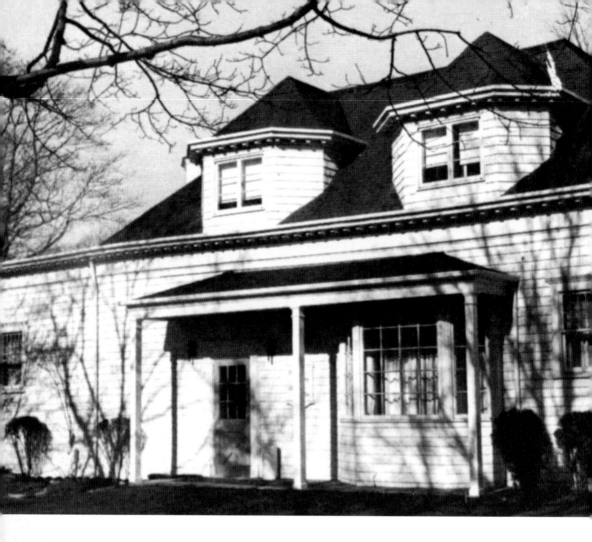

The Little Theater at Felician College has a rich history that includes strong ties to the community. One interesting fact is that it was not always a theater. The Little Theater originated as a carriage

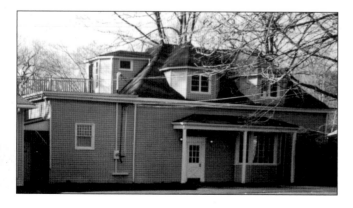

house on the former Prentiss estate. It was converted into a theater in the 1940s. Opera singer Estelle Liebling (coach to Beverly Sills) was artistic director for the theater. Operettas were produced there from the 1940s through the 1950s, and it was also a venue for the professors. The theater thrived through the early 1980s with small-scale productions such as *The Fantastiks* and *The Glass Menagerie,* but usage of the theater began to dwindle. Today, the Little Theater at Felician College has been restored and is offering small-scale productions as well as providing a venue for new artists' works. It is again a bridge between the college community and the community at large.

riginally built *c.* 1836 by Daniel Holsman, a New Jersey senator, this mansion had two artificial lakes on expansive lawns. This photograph shows it as the Santiago Park Hotel in 1870. The hotel, located on the east corner of Union Avenue near the Passaic River, prospered until the recession of the 1870s and was destroyed by fire in 1903. When *Walker's Atlas* appeared in 1876, the area was still sparsely settled, but expansion of home-building development was being encouraged through real estate brokers' advertisements and by the Erie Railroad. Today, Rutherford has examples of many styles, which evolved as preferences, population expansion, and new building materials were developed. Some styles still

Chapter 3

RESIDENCES

in town today are Victorian, Arts and Crafts, English Gothic, Dutch Colonial, Colonial Revival, Georgian, Federal, and Italianate. Rutherford has maintained an essentially conservative nature in its architecture to this day.

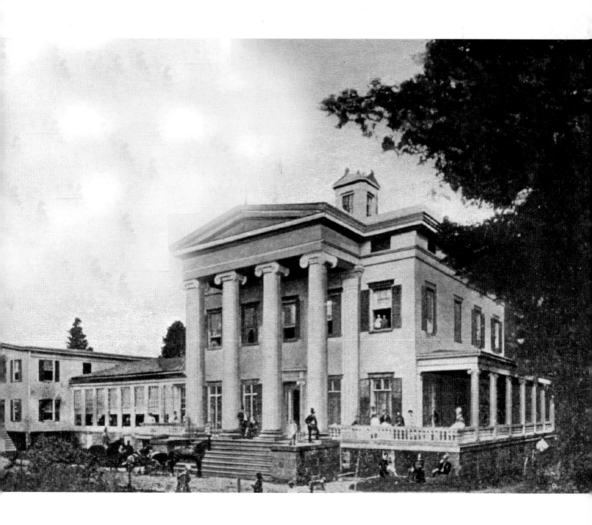

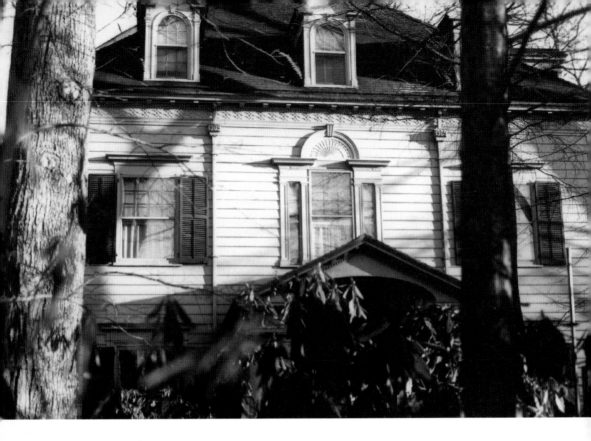

This house was built in 1909 and was the home of Col. Fairleigh S. Dickinson. It is Colonial Revival–Georgian in style, and the year 1909 is carved on both sides of the central bay. Later, it was sold to Williams College in Massachusetts and then to a building developer who was planning on razing the home and the carriage house (set on beautiful grounds with ancient trees and gardens) and replacing them with 10 homes. Historic preservationists in town, with a committee organized by former mayor Andrew Bertone, saved the house. The carriage house was torn down, and five homes were built around the original house. The new homes are attractive residences, which maintain the character of the Ridge Road district. The home was the birthplace of Sen. Fairleigh Dickinson Jr., whose father was cofounder of Becton Dickinson & Company. The house has remained unchanged.

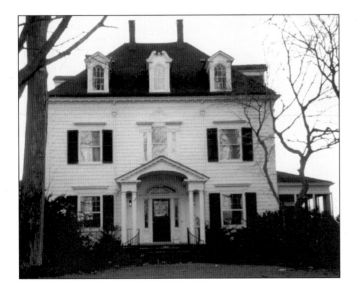

This home was built *c.* 1897–1902 and was originally owned by Maxwell W. Becton, a founder of Becton Dickinson, the well-known international medical-supply firm. (The Becton family contributed a great deal of time and energy to the town of Rutherford.) The style of this house is vernacular Colonial Revival. It has corner pilasters, dentil moldings and curved bay windows. Originally, there was a slate roof, which had to be replaced. Later, the home was owned by Mr. and Mrs. Peter Sammartino. Peter Sammartino was instrumental in the founding of Fairleigh Dickinson College in 1942. The photographs show the continuity in the appearance of this well-preserved home.

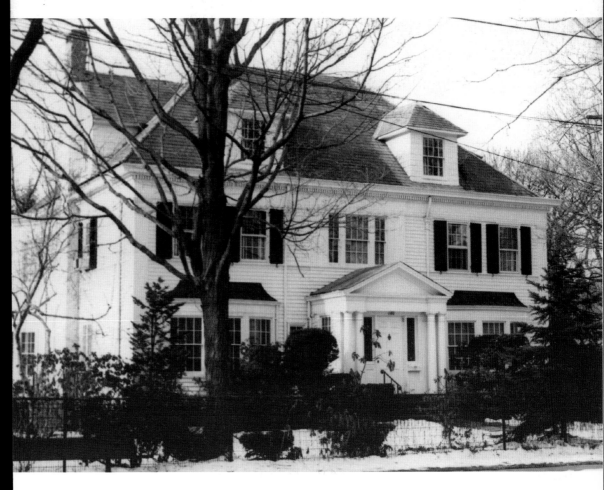

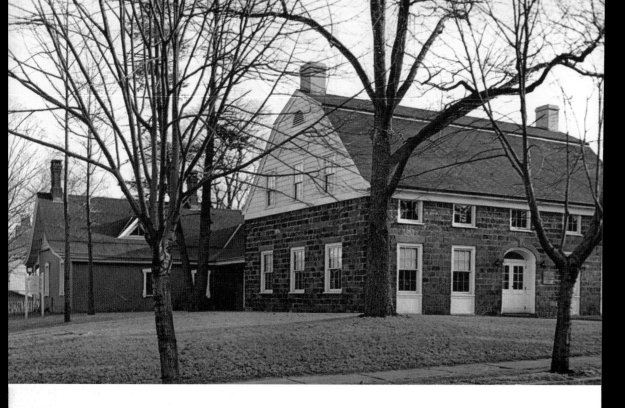

Early stone houses are known by the names of their owners. In this case, it is complicated because there are two different houses on this site. The Kingsland House, built in 1810, is also known as the Yereance-Kettel House. The Outwater House (also known as the Ackerman House), built *c.* 1818 in East Rutherford, was relocated to this site in 1956. Today, they are known as the Kingsland-Outwater Houses. They are listed on the New Jersey Register of Historic Places. They are significant for their association with the exploration and settlement of the Bergen County area and the state of New Jersey for the unique method and materials used in their construction. The buildings are now owned by the Canaan Presbyterian Church. The 1956 photograph shows the buildings, and the more recent photograph is of the Daughters of the American Revolution, who were responsible for placing a plaque at this site.

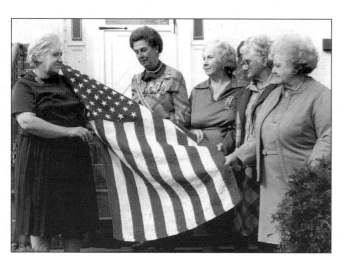

Sarah A. and Philiteus Maison, who sold the parcel of land to Frank and Emma Beasley in April 1910, purchased the property for this house in 1894. Construction of the home was started, and the Beasleys were soon living in their new Craftsman Bungalow–style home. (Frank Beasley was an assistant postmaster of Rutherford.) They sold the home to Cyprian Cyrail Hunt and Uster Theodora Hunt in August 1917. The house was called Huntrest. This is a completely distinctive home, unique not only in Rutherford but also throughout the state. It exemplifies a strong Japanese influence but it is a mixture of many styles and ideas. In general, this is a product of the Arts and Crafts movement, of which there are relatively few examples in Rutherford. The current owner is seeking to place the home on the New Jersey Register of Historic Places.

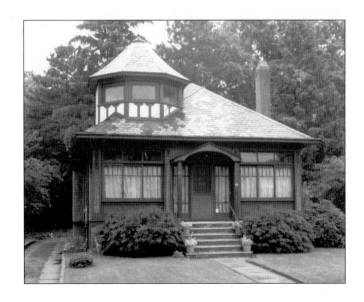

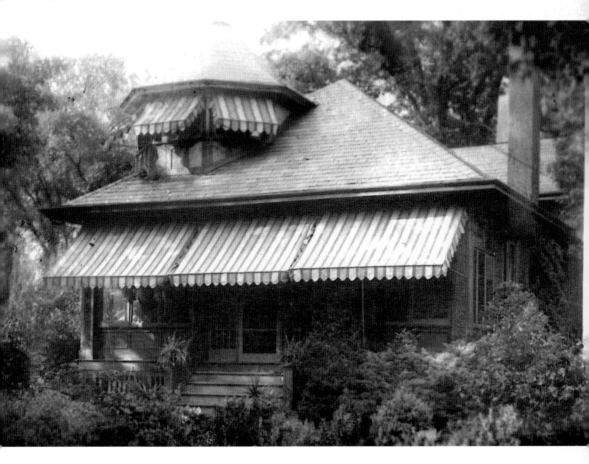

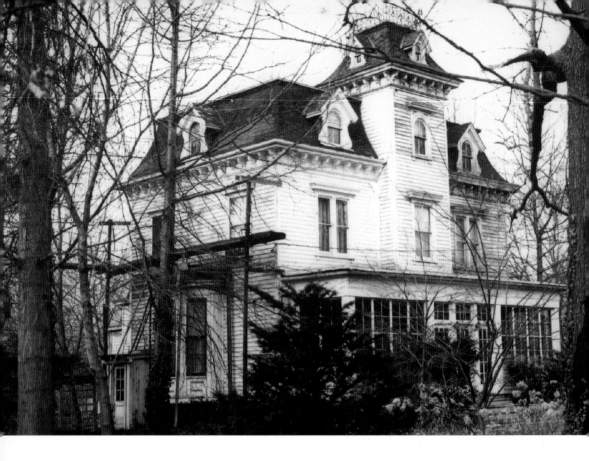

This Second Empire–style home no longer exists but is of interest because its original owner was Joseph P. Cooper, who was among Rutherford's prominent early citizens and was mayor from 1891 to 1893. He was also the first president of the town library. The J.P. Cooper Lumber Company was located in the area for a long duration. Cooper came to Rutherford in 1866 and built his home

c. 1868. (It appears on the 1869 map of the Rutherford Park Association.) The home was an exquisite example of the Second Empire style, with details of small dormer windows inserted even in the mansard roof of the central front tower. I also had a circular driveway in front. The house had other owners after the Coopers; it eventually fell into disrepair and was razed. The present home on that site, however, is a lovely addition to Rutherford.

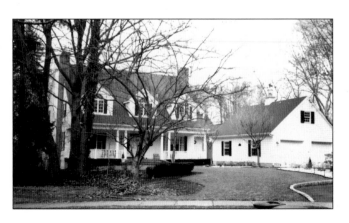

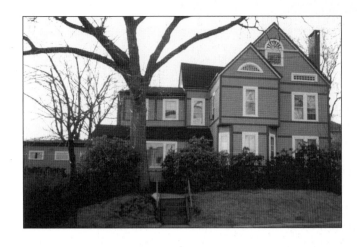

'And the front stairs have been freshly painted . . . the whole house is waiting for you." —William Carlos Williams.

This home was also a physician's office, which holds special significance for people in the Rutherford area for various reasons. To some it means history, to others, caring. Still to others, it is simply a beautiful house where Dr. William Carlos Williams, the Pulitzer Prize–winning author, and his son nurtured local families. The home is on the New Jersey and National Registers of Historic Places and is beautifully maintained. It is an irregularly shaped vernacular Queen Anne structure with a gable roof. On the second floor is a room that served as Williams's study, where he wrote some of his later poetry, especially after his retirement from medical practice in 1951. The early photograph shows Williams, and the recent photograph shows his Rutherford home.

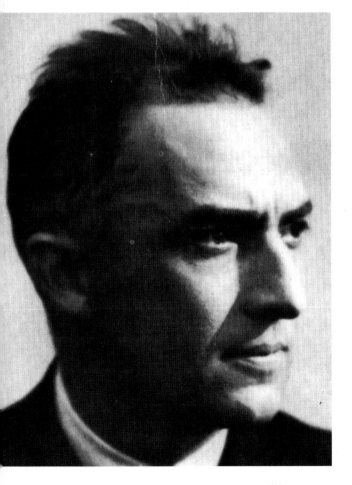

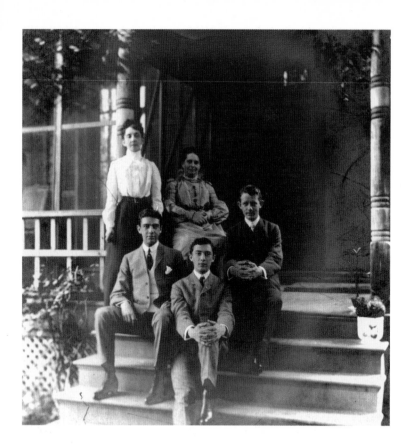

"A house is sometimes wine. . . . The house seems to be protecting them. They relax gradually as though in the keep of a benevolent protector. Thus the house becomes a wine." —William Carlos Williams.

This home on West Passaic Avenue is considered to be the home in which William Carlos Williams, recipient of the Pulitzer Prize for poetry, and his brother Edgar Williams, renowned architect, grew up. The *c.* 1900 photograph was taken on the front porch. The woman standing is William and Edgar Williams's mother. Seated in front of his mother is Edgar; to the right of Edgar is William Carlos. The home is a vernacular Queen Anne–Colonial structure, which has been carefully maintained. In the breakfast room, there are original paintings on the walls by Edgar Williams. One painting depicts the family's first home in New Jersey. The recent photograph shows the current homeowners and friends.

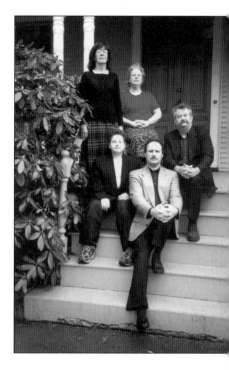

One of the most frequently used architectural styles in Bergen County in the 1860s and 1870s was the imposing Second Empire style. It was favored by Elisha Charles Hussey, an architect and author who lived in Rutherford c. 1867. Hussey's *Victorian Home Building* (c. 1876) covers buildings in "over 250 cities, towns, and hamlets," but no town is given so lengthy a description as is Rutherford. Three lots on Walker's 1876 map are identified as Hussey's property. Maple Street still has a Hussey brick house. There are other Second Empire homes in Rutherford, many built for Rutherford's leading citizens. These images show an illustration of Plate 22, the pattern style in Hussey's book, and the home as it appears today.

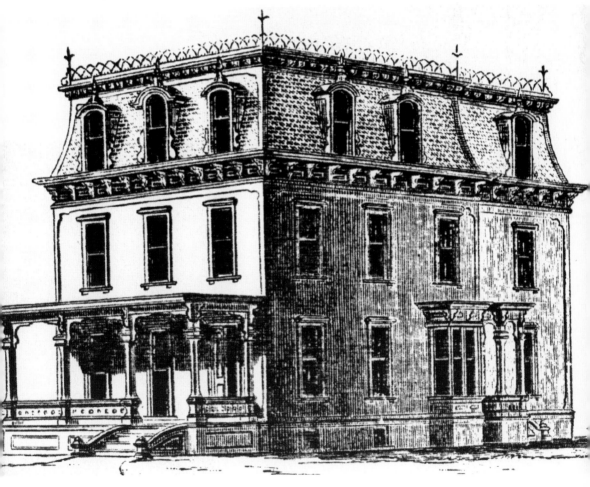

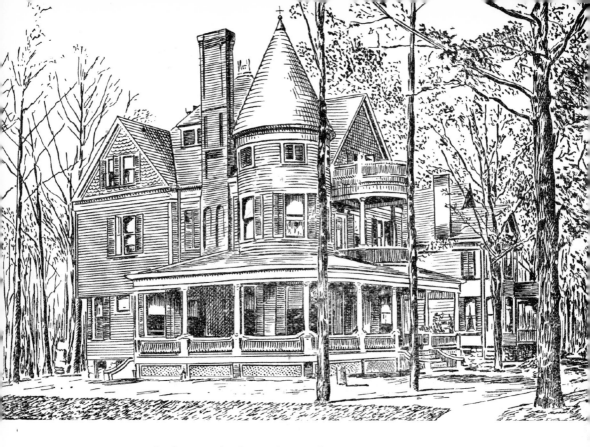

This house is the former home of Mrs. Isaac Lord, daughter of Henry Outwater. Well-known architect Herman Fritz, who used Queen Anne–style plans with an elegant restraint, designed it in 1875. It is eye-catching with its cylindrical tower, high chimney stack with recessed panels, and the curved wraparound porch. (Captain Outwater was the grandfather of Henry Outwater and was an officer in the army of the Revolution. Captain Outwater's son, Richard Outwater, built the old homestead of stone on the Hackensack Road in 1821. Richard was at one time a teacher and was a senator for three years. His son Henry, father of Mrs. Isaac Lord, succeeded him in the old stone homestead and raised three daughters there. This is the same house, which was moved to Union Avenue now owned by the Canaan Presbyterian Church.) The earlier picture is from 1895. The recent photograph of Mrs. Isaac Lord's former home shows the now enclosed porch.

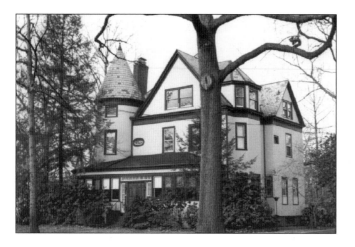

There is a romance to reviving old houses and a great deal of satisfaction in owning a piece of history. An excellent example of a restoration in Rutherford is the home of John and Diane Moe. Built in 1896, this particular home had been converted into a four-family unit. They successfully converted it back into a one-family home with careful research combined with patience. (Currently, in New Jersey, the Uniform Construction Code allows historic buildings to maintain their original character under various circumstances.) The earlier picture shows the house after roof-shingle siding was removed to expose the original wood lapboards. Fortunately, the original lapboard siding underneath was in good condition, but multiple layers of paint also had to be removed. The recent photograph shows the completed restoration.

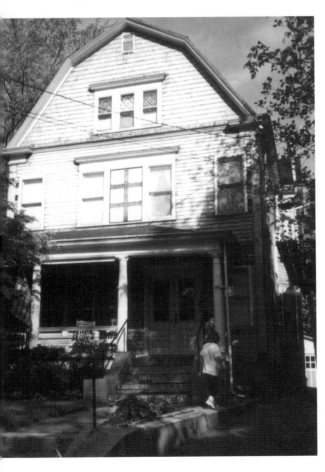

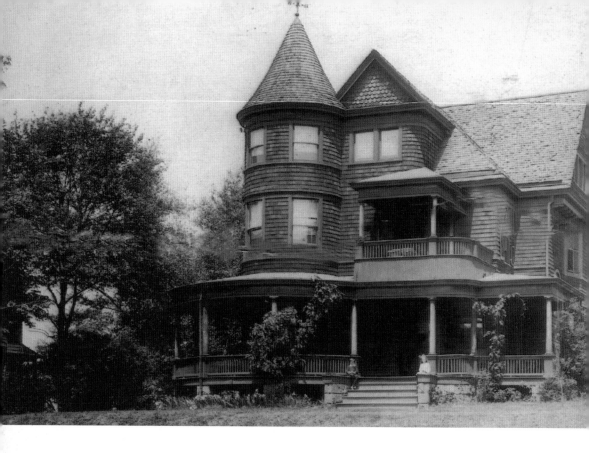

This beautiful house was constructed between 1876 and 1897. It was designed in the vernacular Queen Anne style and has a cylindrical tower through three stories. Its porch curves around the tower and has Tuscan columns on pedestals with simple balusters. It originally had a small open porch on the second floor (which is now enclosed) set into a curved bay. It is very spacious, with 10-foot ceilings and six bedrooms, and is an excellent example of Victorian–Queen Anne architecture. It is set on a large lot with a low pebble wall around the front of the property. The original owner of the house was Louis Lancon, a broker. The older picture was taken in 1908, and the newer photograph indicates that the basic integrity of the home was kept intact. (Above courtesy Bob Giangeruso.)

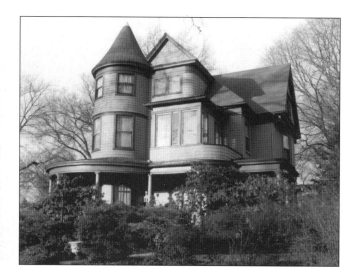

This is an Italianate-style home built in 1871. Not only is it one of the oldest dwellings in Rutherford, but it is also one of the best-preserved homes. It is a fine example of an L-shaped, two-storied structure with excellent proportions and restrained detail set on its original deep lot and merits inclusion in the New Jersey and National Registers of Historic Places. Lafayette Hoag, a black coachman from Georgia, and his wife, who was from Jamaica, purchased this property from the Rutherford Heights Association on May 6, 1871, according to a deed filed in the Bergen County Courthouse. The property was inherited by his daughter Lillian and remained in the family until 1935. A two-story barn in the backyard, with a hayloft, has been converted into a garage. Comparing these two photographs reveals that the home is basically unchanged, although the L-shaped portion is concealed.

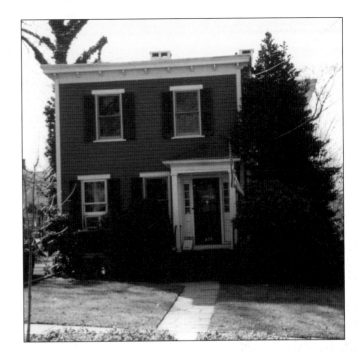

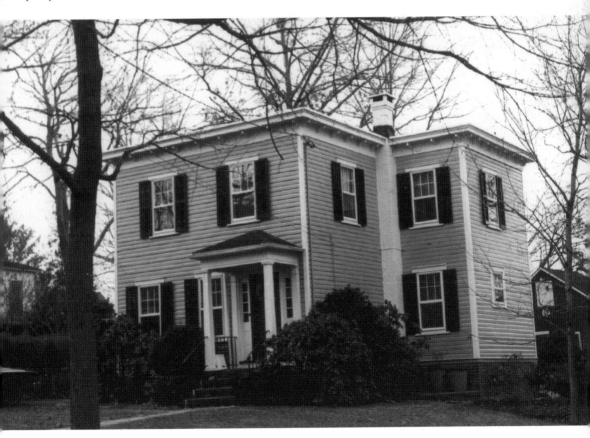

43

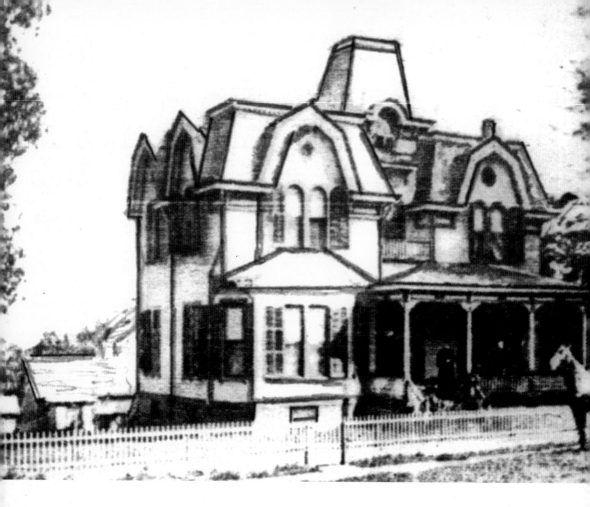

The impressive James Rutherford House was constructed sometime between 1876 and 1895. It is an excellent example of the Second Empire style and has unusual wall dormers and asymmetric

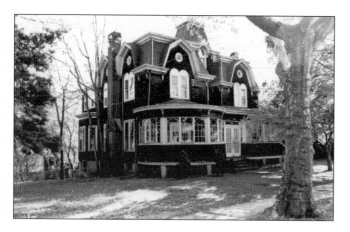

massing. The mansard roof is interesting because of the strong interruptions in the roofline, which is more intricate than the mansard roofs in Elisha Charles Hussey's architectural designs. The 1895 photograph as compared to the present-day photograph indicates a rebuilding and enlargement of the facade porches, which, however, were compatible with the original structure. This building is worth recognition and preservation. Its original owner, James Rutherford, was a dealer in dry goods.

Iviswold, Rutherford's castle, had a beautiful stable building. The architect of the stable was William Henry Miller, who also designed Iviswold. The original brownstone stable, built in 1886, was converted into a meeting place for the Rutherford Woman's Club. (It was originally part of the estate of David B. Ivison.) The style is vernacular French Chateau, with Belleville brownstone walls in the first floor and clapboard above. The members of the club purchased the building in 1924 and held their first meeting here on February 1, 1926. Since that time, it has had a very active membership. This 1940s picture of Mr. and Mrs. Pierce's ballroom dancing classes (a formal white-gloved requirement for many boys and girls of Rutherford at that time) took place regularly for aspiring ladies and gentlemen at the Rutherford Woman's Club. The clubhouse is also shown as it appears today.

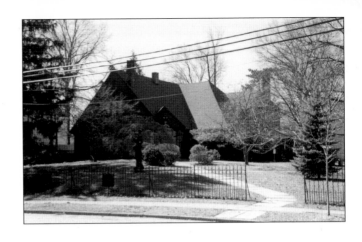

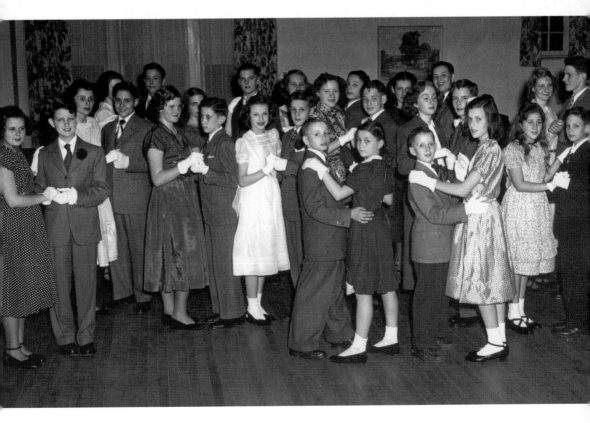

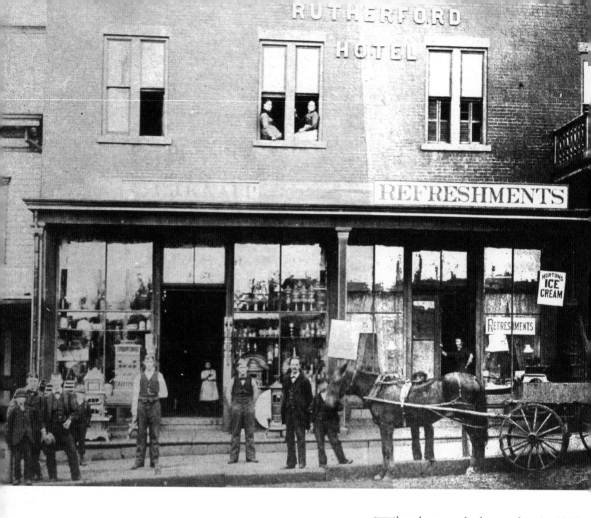

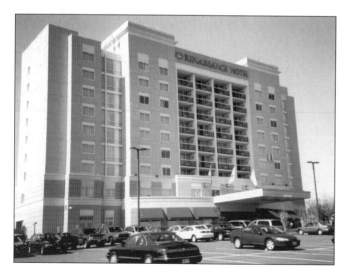

The photograph above, taken in 1880, shows the Rutherford Hotel. It is unclear exactly where this hotel was located, but it is believed to have been on the north side of Station Square. The entire north side of Depot Square, as it was called at that time, was completely destroyed by fire in 1890. The other side of Depot Square was also partially destroyed by fire in 1895. (At the time of the 1895 fire, the Rutherford National Bank was located near the Van Winkle building with its safe on the second floor. The safe fell through the floor and had to be cooled off for several days before it could be removed from the debris. All funds were safe.) Today, the modern Renaissance Hotel, located on Rutherford Avenue, is available for visitors to this area. (Above courtesy Virginia Marass.)

In the early years, the townspeople of all faiths went to services at Union Hall. The Union Sunday School was started in 1859 by Floyd Tomkins. (Union Hall's original location was a high hill where the Bank of New York stands.) W.P. Elliott wrote that it was a frequent occurrence in the summertime to hear the sounds of hearty singing upstairs in Union Hall and quiet preaching downstairs, but good feelings, without friction, always prevailed. The building in the photograph was located on the corner of Park and Rutherford Avenues and was known as the Academy, built by the Rutherford Park Association in the 1870s. The lower floor was an academy, and the upper was originally used as an Episcopalian Sunday school. At one point, political gatherings

and general public meetings were held here also. Ultimately, it became a Presbyterian chapel. The building no longer stands.

Chapter 4

HOUSES OF
WORSHIP

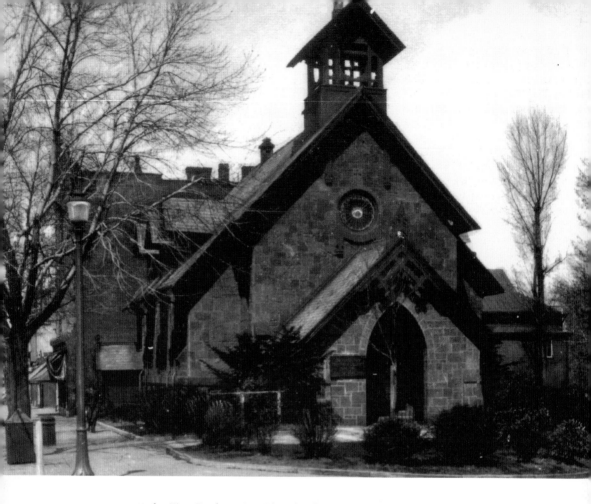

The First Presbyterian Church of Rutherford was founded in 1863. Its first members were Isabel Alden, Janet Blauvelt, Jane Christie, Sarah Crane, William Crane, John Gow, Harriet Hanks,

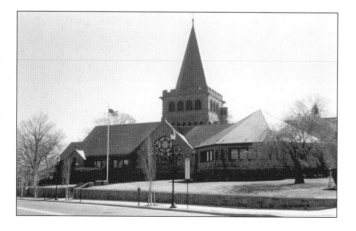

David Ivison, Emeline Ivison, James Jones, M. Cornelia Jones, Eliza Livingston, Agnes McClure, Daniel Van Winkle, and Sarah Van Winkle. Initially, services were held in Union Hall on Ames Avenue. In 1869, construction began on a church building at Park Avenue and Chestnut Street. Elder David Ivison later purchased the building and deeded it to the Rutherford Free Public Library. The present Rutherford Public Library is built on this same site. Some historians believe that stones from the old church were saved and used to build the front of the main entrance, as a permanent memento. In 1890, the present First Presbyterian Church building, an architectural masterpiece in the English Gothic style, was built and dedicated. The photograph above was taken in 1902. (Above courtesy Virginia Marass.)

Until Grace Episcopal Church was opened for worship in 1873, its congregation met in the original Union Hall on Park Avenue. They later met at the Rutherfurd Park Hotel (formerly Edgarston Manor), then at the Academy (at Park and Rutherford Avenues), and finally in the second Union Hall building. On May 11, 1869, the parish was formed. In 1871, Floyd W. Tomkins donated an acre of land for the church building. (Tomkins owned the land where the Iviswold castle now stands. It was a portion of this land that he donated). The church was erected two years later on the corner of Passaic Avenue and Wood Street. An English Gothic–style building, Grace Church was enlarged in 1890 with a new transept and chancel. The 20th century has seen the addition of a rectory and a parish house.

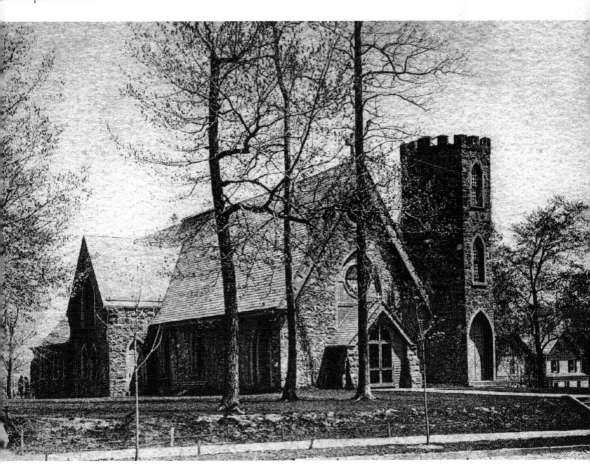

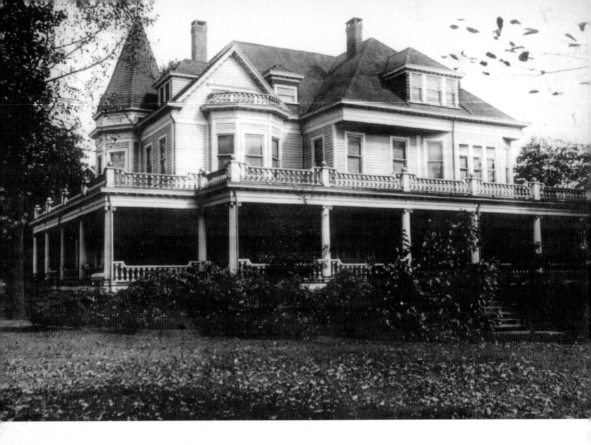

This former home is now a synagogue. It was constructed *c.* 1890 by well-known architect Herman Fritz. The first owners were the Dannheims, and it was later the Willis home. It is a significant example of the architect's work and is mentioned in several publications of the 1890s. Although the building has had alterations and additions, it still remains an excellent example of its era. Recently, a new rabbi has been appointed, Shlomo Levin, to lead this orthodox synagogue. As president of the Congregation Beth-El, Sabetay Behar has worked hard to keep the esthetic beauty of the site by maintaining its old trees. Also, according to Behar, the original carriage house exists and is now used as a dwelling on Hackett Place. Dr. Jean Willis recalls the elegant lifestyle at this home in her formative years and has shared her photograph of the residence as it once appeared.

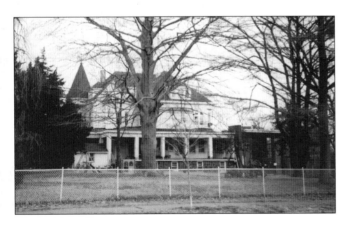

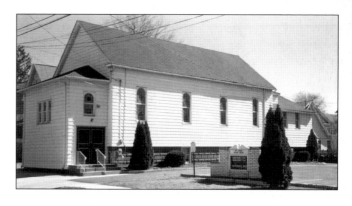

Mount Ararat Baptist Church started in 1893. In the beginning, however, members met in a storefront at 10 Ames Avenue. An old church was finally rented on Park Avenue where the Holman Building now stands. In 1902, the congregation built a small church on Elm Street. In 1919, under the leadership of Rev. A.D. Jones, the present church was constructed. Madeline Chase wrote, "The erection of the new building is not something that is written down on paper matter-of-factly; there had to be workers, men and women of character, those who had no fear of work and there was much to try their souls." The lovely church has four bays with arched colored-glass windows, a gabled roof, and double side-entry doors. The cornerstone was laid by Reverend Penn, the only mason in the vicinity. Traditionally, a mason had to preside over the laying of a cornerstone.

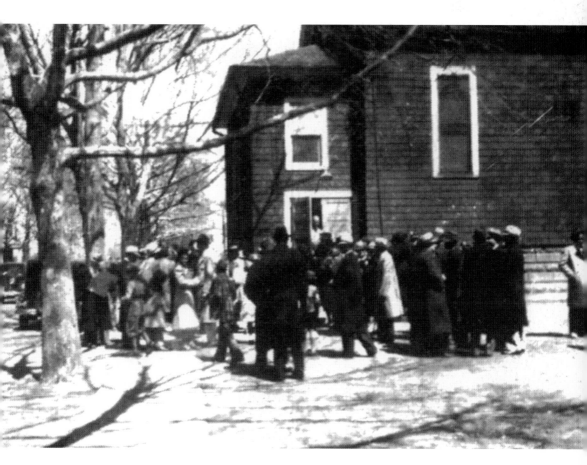

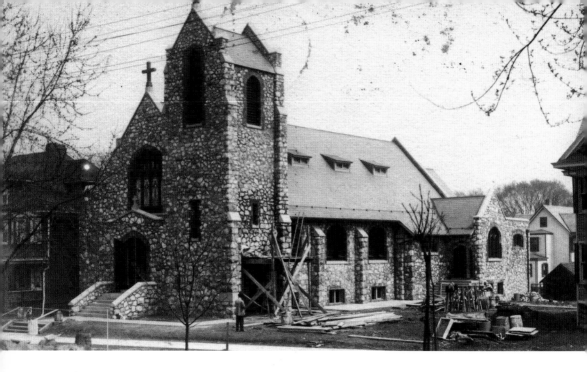

On April 19, 1908, a rainy Easter Sunday morning, 55 men, women, and children gathered for an 8:30 mass at the borough hall, marking the beginning of St. William's Mission, the original name of St. Mary's. The church was incorporated as St. Mary's Roman Catholic Church in June 1909. The organization of a Sunday school followed the incorporation of St. Mary's, along with plans to erect a church in Rutherford. New York architect H.A. Wiseman completed plans for the design of the beautiful English Gothic structure, which served the Catholics in the community from 1910 until they moved into a new and larger church–auditorium built on the corner of Ames and Home Avenues in the 1950s. Eventually, the original church was torn down. The early photograph shows construction of the English Gothic church in 1910. (Above courtesy Virginia Marass.)

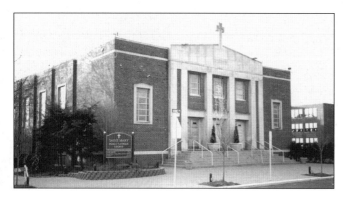

The Rutherford Methodist-Episcopal Church was started in 1870. This congregation is now known as the United Methodist Church. Services were first held in a rented house and then in Union Hall (on Ames Avenue) until 1881, when the congregation built a chapel on Ames Avenue on land donated by Mary Ames of New York City. From 1893 to 1896, when the present church edifice was dedicated on land adjoining the parsonage, the congregation met at the Union Club hall and later in Ivison Hall (the old library building, which was originally the First Presbyterian church). During the succeeding years, the church's physical plant has been enlarged and remodeled a number of times, providing facilities for a Sunday school, church offices, and fellowship activities. (Below courtesy Virginia Marass.)

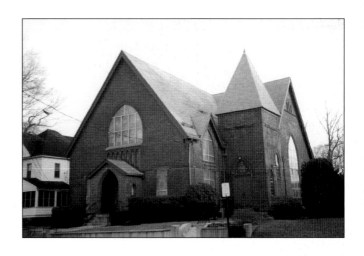

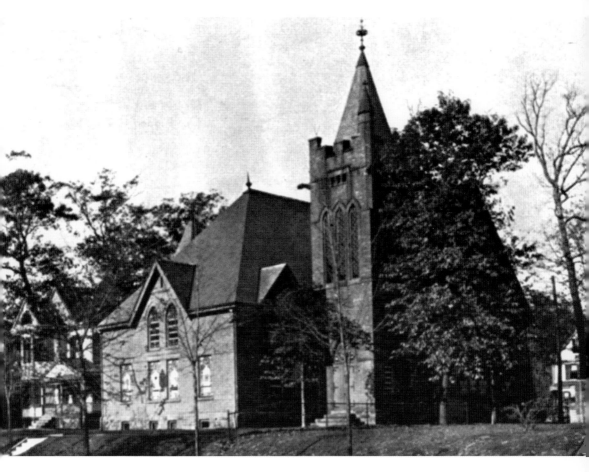

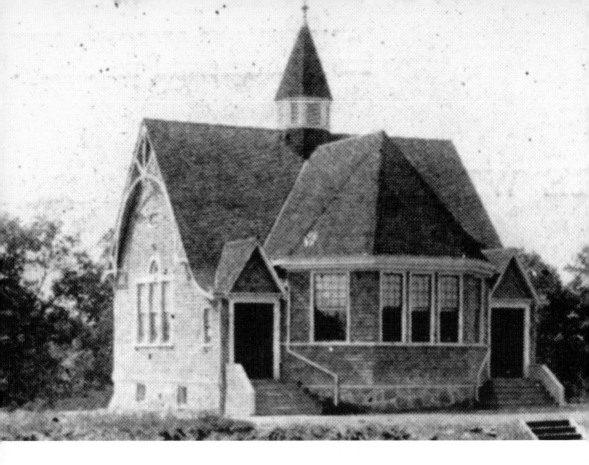

The Rutherford Congregational
Church began as a Presbyterian
Sunday school, meeting in a vacant store
on Union Avenue near present-day Union
School in 1893. Assisted by the parent
church, they erected the Emanuel Chapel
of the Rutherford Presbyterian Church at
the corner of Union and Belford Avenues
in 1898. Three years later, they became an
independent body. However, the West End
was sparsely populated at that time, so the
new church desired to move closer to the
center of town. The parent church,
however, believed that the town could
adequately support only one Presbyterian
congregation. Therefore, on October 20,
1907, Emanuel Presbyterian reorganized as
the Rutherford Congregational Church.
Following the loss by fire of the original
church on the corner of Carmita and
Washington Avenues in 1923, the present
building at the corner of Prospect Place
and Union Avenue was completed in
1925. The above photograph was taken in
1905. (Above courtesy Virginia Marass.)

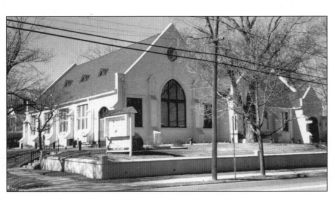

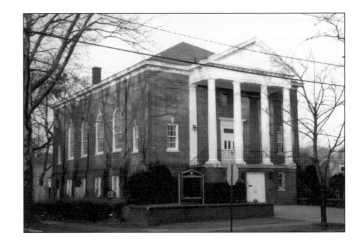

The original First Church of Christ, Scientist was built in 1912 on the east corner of East Newell and Park Avenue. (The building no longer exists.) However, the first service held by the Christian Science affiliation was in November 1906 in Rutherford. The second building, which was built by the Christian Science community, is now the home of the Iranian Muslim Association of the Eastern United States, at the corner of East Pierrepont and Lincoln Avenues. The beautiful building is Greek Revival in design. The 1912 photograph shows the original church.

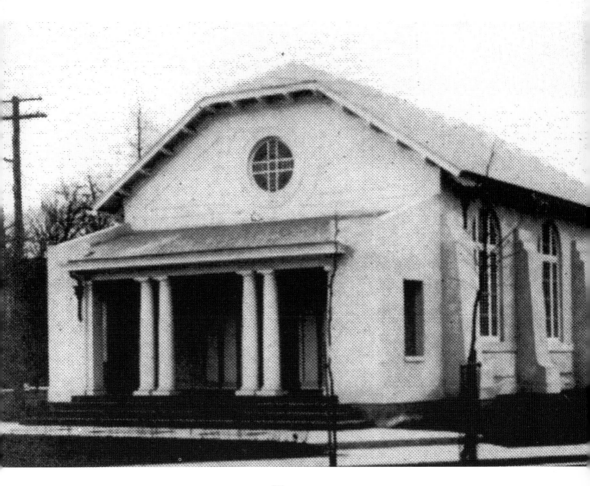

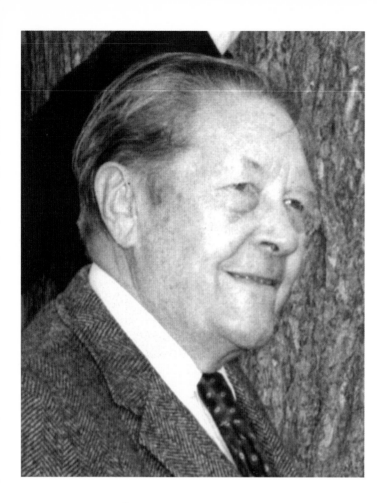

St. John's Evangelical Lutheran Church is located at Mortimer and Fairview Avenues. The original structure was completed in 1930 and, in 1955, an addition was added to this church made of random Ashlar stone. The church was dedicated in September 1930. It is a simplified Gothic style, which was popular for ecclesiastical architecture in the early 20th century. Notable in the building are the beautiful stained-glass windows. The photograph shows John C. Korn, a member of the New York Stock Exchange and a very active member of this Lutheran congregation. He lived within 100 feet of the church at 137 Mortimer Avenue and was one of the effective leaders and benefactors of St. John's. Harry Doland, who was the comptroller of the Curtis-Wright Corporation and who lived across from the church, was also a great contributor to this congregation.

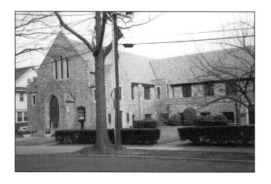

The location of this building at 70 Home Avenue is currently the home of the Annunciation of the BVM Ukrainian Catholic (Byzantine Rite) Church. Originally, this site was donated by Mr. and Mrs. H.E. Bell, where a church was dedicated for the Unitarian Society of Rutherford. In 1914, a parish house was added. The first Unitarian service was held in Rutherford at the residence of the Bells on October 3, 1891, when 22 people pledged themselves to the support of the society. For six months, public services were held in the Old Union Club building and then in a hall over the engine house on Park Avenue until their church was dedicated. The building remains relatively unchanged, but the stained-glass windows, which can be seen in the 1900 photograph, are no longer there.

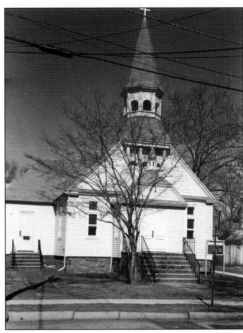

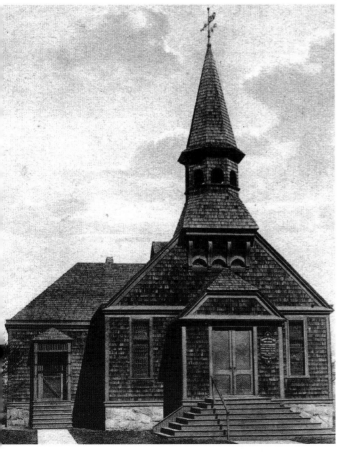

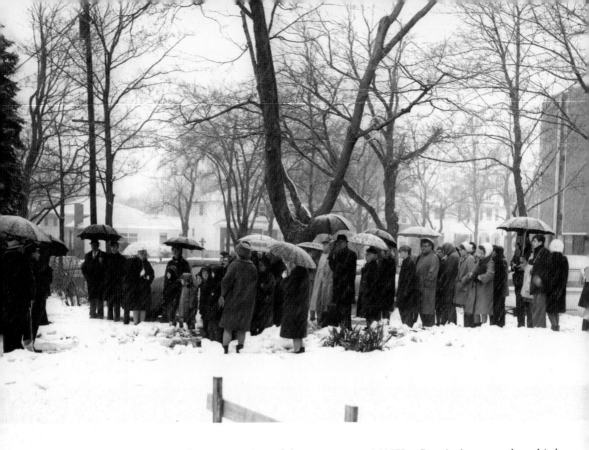

Prior to the construction of the Rutherford Bible Chapel, the members met in a small building on the corner of Union Avenue and Elm Street. At the dedication, Arthur S. Manger spaded out the first shovelful of earth at 161 West Passaic Avenue, where his home had stood from 1905 until it was demolished in 1968 to make room for the new church. Two of the church trustees at that time were Chester W. Schuster and Dr. Samuel B. Scales. The devoted parishioners are shown attending the groundbreaking ceremonies on February 23, 1969, in the snow. The other photograph shows the beautiful building as it appears today.

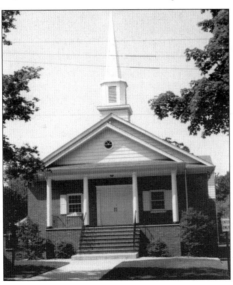

In 1819, there was a tiny schoolhouse (18 by 20 feet) on Neck (Meadow) Road, but it was soon abandoned. However, it was the forerunner of a current school system of six schools. According to Garrabrant Alyea grandfather to Brant Alyea, who attended Rutherford schools and became a Minnesota Twins outfielder), there were two schools between Hackensack and the Belleville Turnpike, but it was not thought difficult for even the smallest child to walk four miles to school. The district built another schoolhouse on Meadow Road in 1850. The teachers were George Brinkerhoff, J.P. Jones, E. Vreeland, a Mr. Gow, George Parsell, and G.R. Alyea. The school was kept open the entire year (except two weeks). Less than 20 years

SCHOOLS

later, the population began to increase and the Park Avenue school was constructed. The other schools followed. This photograph shows May Day celebrations at Washington School in 1943.

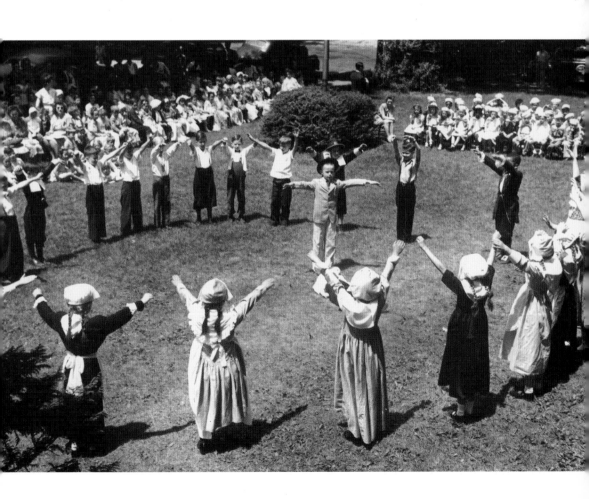

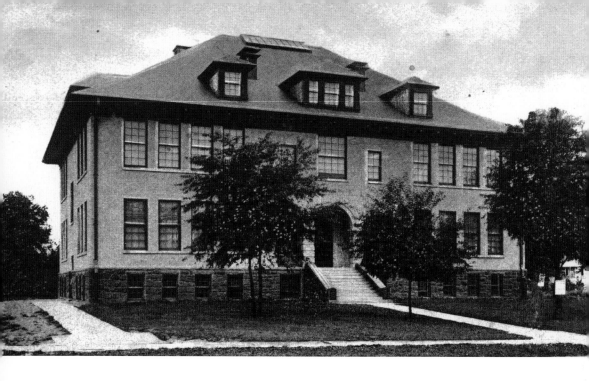

Pierrepont School was built in 1908 in a residential location. The building structure is vernacular Renaissance Revival style with an exterior of yellow brick. The original building had an addition built on the east side. It is a nice example of an early-20th-century elementary school building following the contemporary taste for balanced Neoclassical design with Renaissance details and could be eligible for the New Jersey and National Registers of Historic Places. The later addition is a bit starker but harmonious. Today, children in kindergarten through eighth grade are prepared to function in a diverse society with a rigorous curriculum designed to challenge students. Modern technology is viewed as a valuable tool in order to enhance learning. Every classroom is equipped with computers and curriculum-related software. The picture of Pierrepont School was taken *c.* 1910, before the addition was built. The 1971 picture shows June Fejko's kindergarten class. (Above courtesy Bob Giangeruso.)

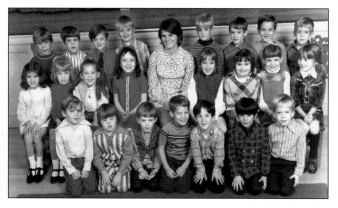

This building, located on Union near Belford Avenue, was constructed in 1926 and designed by architect Ernest Sibley. It is a red-brick structure in the Colonial Revival style. This is a fine example of a school building of the mid-1920s. It is well sited and pleasingly landscaped. An earlier school on this site, built in 1892, was replaced by this school. The building is eligible for the New Jersey and National Registers of Historic Places. Union School is a vibrant learning center where children from kindergarten through eighth grade are guided by a professional staff whose primary mission is to provide an educational climate that is challenging yet supportive. It is well equipped with modern technological tools to teach the students in these necessary skills. The school has remained relatively unchanged since the 1945 photograph was taken. (Below courtesy Bob Giangeruso.)

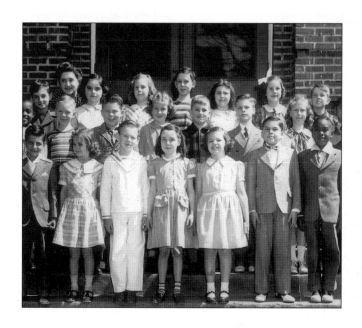

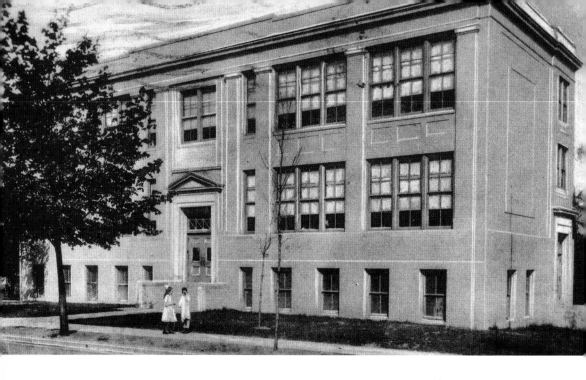

This elementary school is located on Wood Street and Washington Avenue. It was constructed in 1913 and is vernacular Renaissance in style. It has a brick foundation, and the walls are of common bond brick. The building displays the prevailing taste for conservative designs of balanced masses, pavilions, and some slight classic Renaissance detail. It has a balanced design of central, side, and end pavilions. The roof cornice has dentil molding. Washington School is a community-based learning center with activities that abound throughout the year. Parents and teachers, as well as local professionals and businesspeople, work side by side to enhance the educational experiences of the children. In the Rutherford school district, curriculums are reviewed and rewritten to keep up with the times and meet or exceed New Jersey State Core Curriculum Content Standards. Washington School has remained the same since 1910, but the mode of dress has changed since then.

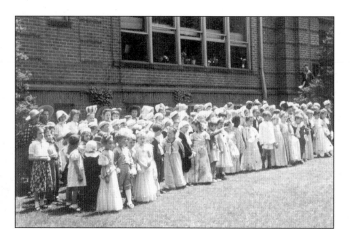

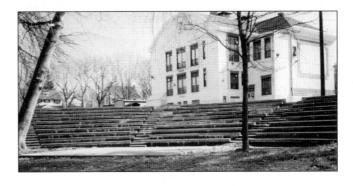

This elementary school is located on Montross and Vreeland Avenues. It is interesting to note that a public referendum to build an elementary school one block south of Union Avenue on Kip Farm property failed to pass in 1911. A second referendum the following year passed to build two smaller schools of six classrooms each. The original school's plans were cut in half for two smaller schools. Lincoln and Washington Schools were both built in 1913. They have been used continuously to house grade-school children. The building, made of poured concrete with a brick foundation, is vernacular in style. It has brick lintels over each window, with a rusticated keystone over the center of each first-floor window. It has a gambrel roof, with sides having hipped roofs. This school has a wonderful outdoor amphitheater used in fair weather for various activities. The photograph below was taken in 1915. (Below courtesy Virginia Marass.)

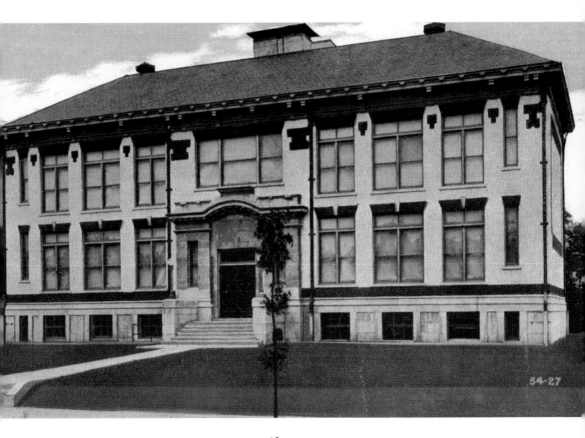

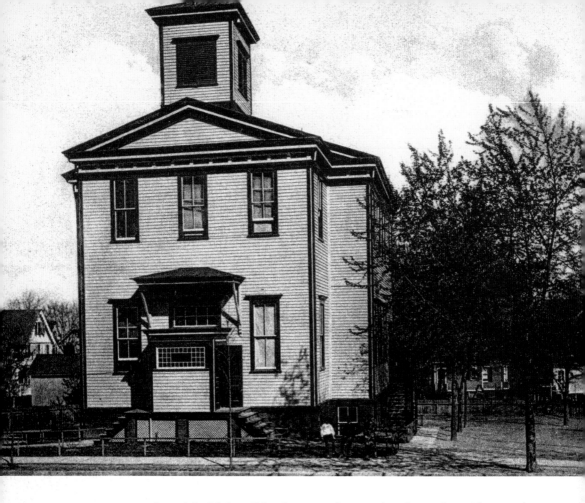

The original Sylvan School was razed, and a new school was built on the site in 1917. Today, Sylvan School is one of the three elementary schools in Rutherford. It is a small school of about 150 students. It offers a top-quality education and provides two classrooms for special education. Learning takes place for all students through formal curriculum and varied practical learning experiences. In 1908, the original school was a wooden building. It was later replaced by a larger school of brick, which is still in use today.

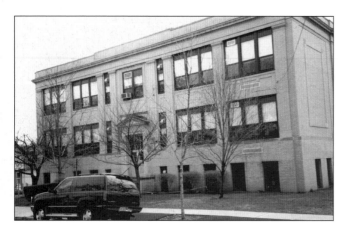

St. Mary's School consists of a high school and a grammar school. The high school is well sited on its corner lot and illustrates the preference for building in the Colonial-Classic style in 1931. The decorated panels on the windowless end pavilions have symbolic designs: an open book surmounted by a burning lamp, a collage of a compass, a flask burner, and a beaker. The high school has Corinthian columns through two stories, with entablature at angles of the entrance bay and smaller pilasters framing the door. The high school was founded in 1930 and was originally located in the grammar school, which predates it. In 1935, the high school moved to its present building at the corner of Ames Avenue and Chestnut Street. The high school is shown in its early years with a more recent photograph of Olga Sheridan's kindergarten class.

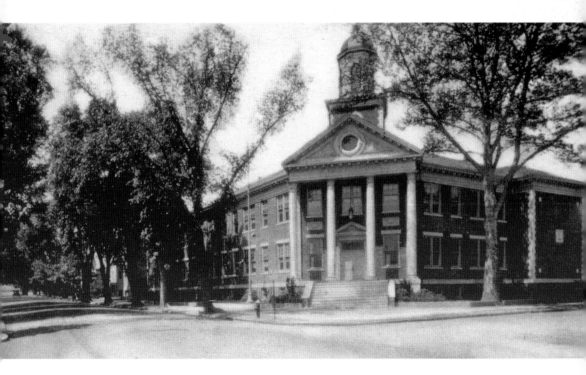

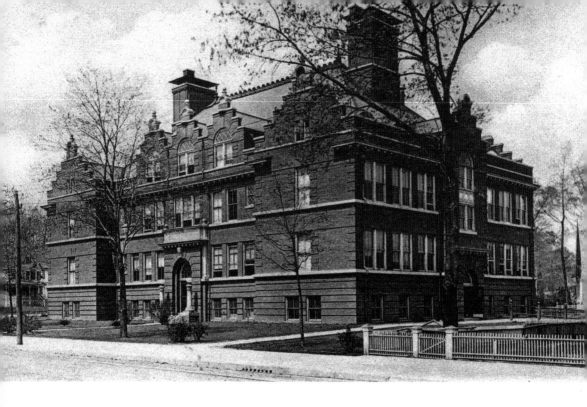

Park School on Park Avenue was initially a high school, and the present building is the second school built on this site (in 1901 and 1938). It was redesigned as a borough hall in 1938 and reduced to two stories. In 1922, a new high school was constructed. This school has been honored as a National Blue Ribbon School of Excellence. The Distinguished Graduates Award is presented annually to an honoree who has made an outstanding contribution at the national, state, or local level. Some of the honorees to date are Peggy Noonan, a writer of Pres. George Bush's "thousand points of light" speech; Ferdinand Petrie, an artist; John Decker, an aerospace engineer for Hubble; Herbert G. Miller, beloved physician of Rutherford; Sr. Sylvia Postles, Class of 1958, a Maryknoll sister; and Barbara Chadwick, former freeholder and mayor. Pictured are the second Park School and the present Rutherford High School.

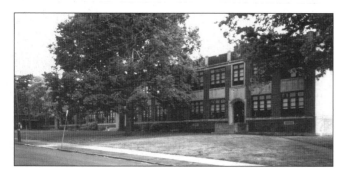

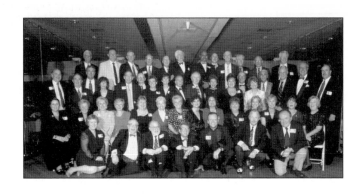

The Class of 1958 is an excellent example of the camaraderie, caring, and friendships that form and last for a lifetime in Rutherford. Since their days in the Rutherford school system, the members of this class have retained their friendships. Every five years, a well-attended reunion is held. The contributions made by this group are remarkable. The careers of this one class alone include physicists, airline pilots, professional baseball players, scientists, principals, teachers, coaches, writers, doctors of medicine and psychology, inventors, attorneys, retailers, restaurateurs, and businesspeople. The photographs are of grade-school days and a recent reunion of the Class of 1958.

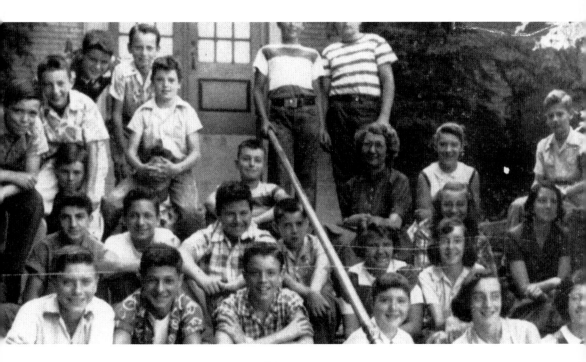

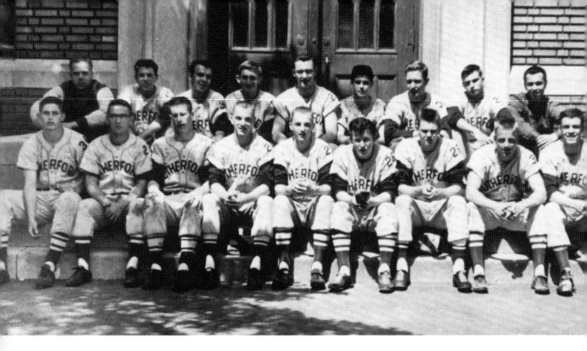

Rutherford has always had a variety of sports programs that culminated in high school varsity athletics for both boys and girls. Appropriate training gives the individual the chance to go on and participate in varsity college athletics with the further opportunity to become a professional athlete. Examples of this type of achievement are shown in two individuals—Bill Hands and Brant Alyea, who were varsity baseball players on the 1958 Rutherford High School baseball team. Hands was signed by the San Francisco Giants Minor League organization and was eventually traded to the Chicago Cubs. He became a 20-game winner and an All-Star for the Chicago Cubs. Alyea moved into the Minnesota Twins organization, moving through the Minor League system, and became an outfielder for the Minnesota Twins. Brant twice had seven RBIs in a game.

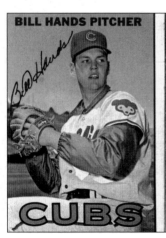

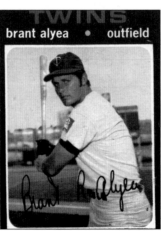

Rutherford today is a commuter's dream town that maintains its "Small Town, USA" atmosphere and is conveniently located near New York City. Every means of transportation is available here. At one time, however, Rutherford was farmland with dirt roads, and travel was by horse and buggy. With the advent of the railroad, change came rapidly. Wealthy New York businessmen started coming to this area to vacation. Land companies then developed, such as the Mount Rutherford Company. With increased population and motorcars, improvements came naturally to the roads and railroads. Today, New Jersey Transit's Secaucus Transfer Station will link Bergen County train lines with the Amtrak East

Chapter 6

TRANSPORTATION

Coast Boston–Washington line, and there will be direct train service to midtown Manhattan. Airports and major highways are easily accessed. This photograph was taken at Christmastime on Park Avenue *c.* 1947, during the in-between years. (Courtesy Virginia Marass.)

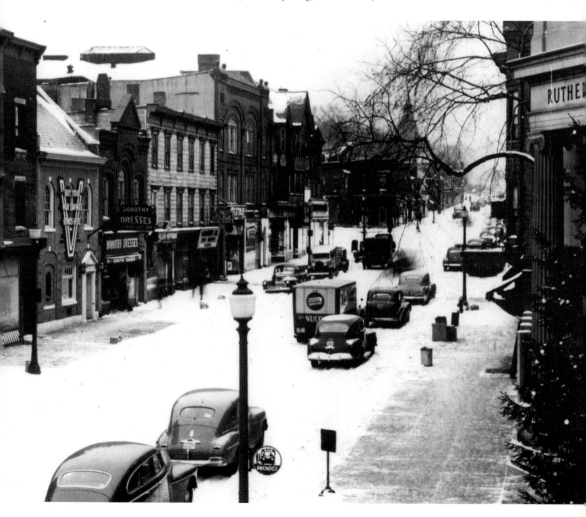

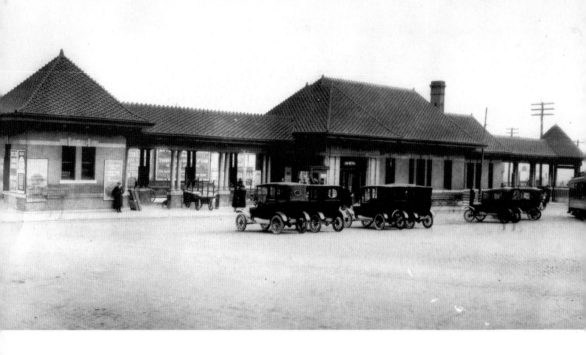

For many years, the Erie Railroad had only a little wooden station. With improvements to the roadbed in 1897, the Erie included a new station. (Two stations preceded the current structure.) In 1898, Richard Shugg wrote of the topographical aspect near the station, "Looking westward from this depot two modest looking hills completely shut out a view of the lands lying beyond them. The more southerly one is now dignified by the name of Mount Rutherford, the other a smaller one arose in a depressed conelike shape directly back of the depot, although the lesser in size is the more honored of the two, in that on its apex stood the emblem of the intelligence and spirituality of the village, Union Hall, the place of assemblage for the Union Church."

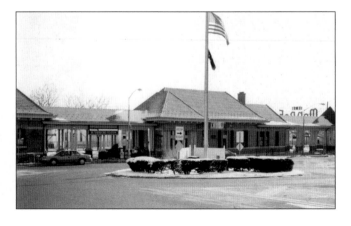

Opposition against a railroad was high in 1830. Rutherford's Dutch farmers felt that a railroad would hinder navigation on the Passaic and Hackensack Rivers. However, a railroad bill was passed in 1831. The first train was a double-decker coach drawn by "fleet and gentle horses" with "three splendid cars." In 1835, the *McNeil* was the first steam engine to pass through, and the second was the *Whistler*. (Whistler married McNeil's sister; their son painted the Whistler's Mother portrait.) In 1846, the township was without a center but found springs in this area. The railroad made the Boiling Springs Depot here. "There was no other building near and very few in sight," said Floyd W. Tomkins, the first outsider to purchase property from the farmers for purposes other than farming. In 1899, travelers on the Erie

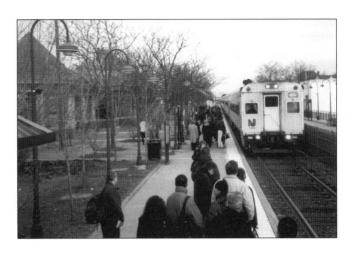

Railroad were struck by the admirable location of Rutherford. Today, the improvements continue.

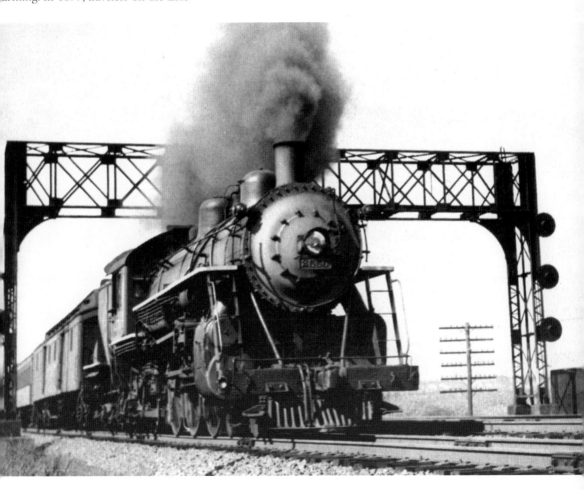

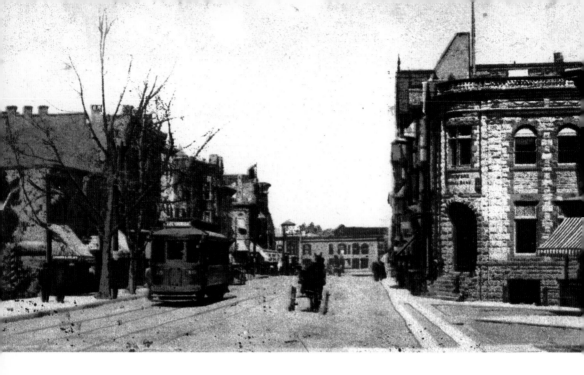

Rutherford had trolley car service on Park Avenue at one time. One of the regular stops was near Addison Avenue. The trolley traveled from Newark to Hackensack and was a very convenient mode of transportation in the late 1890s. Today, the macadam on Park Avenue covers both cobblestones and the original trolley car tracks. Modern cars stream up and down Park Avenue nowadays, seeking parking spaces in order to eat at the wonderful restaurants or purchase items from the stores on the avenue. In the early-1900s photograph, the trolley car can be seen traveling up Park Avenue and heading toward Newark, with a horse and wagon traveling in the opposite direction. In later years, the Public Service Bus Company replaced the trolley cars with bus service from Hackensack to Newark via Park Avenue and Ridge Road. (Above courtesy Virginia Marass.)

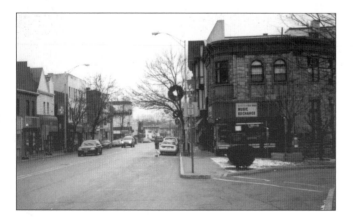

Public transportation is encouraged today for convenience and for environmental reasons. Rutherford has had bus service (particularly to New York City) for many years, as can be seen in these photographs of Station Square in Rutherford. The buses still pick up passengers at the same location. The buses of the 1930s had gasoline engines located in the front, and the modern buses have diesel engines that are in the rear. In the past, up until very recent times, there were four or five different bus companies that had routes that ran through Rutherford to New York. Intercity Bus Company had a route between Paterson and New York called the Route 30. The majority of today's bus routes are run by New Jersey Transit, which also runs the railroad transportation.

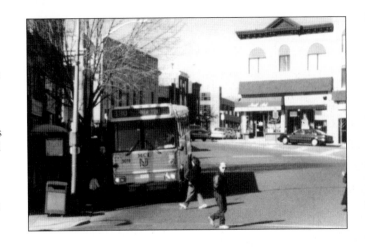

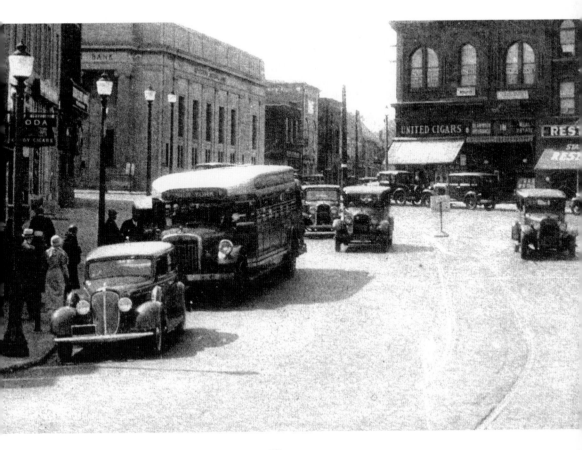

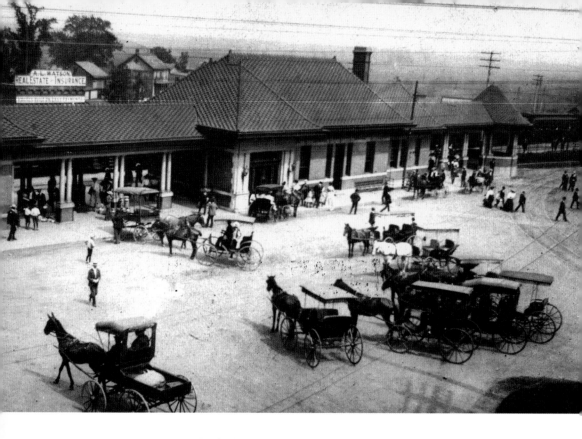

In 1892, Rutherford had a population of about 4,000 people. Transportation was by foot, bicycle, or horse and buggy. Taxi service c. 1903 was by horse-drawn carriages called hacks, which were hired by visitors who arrived by train. There were a number of livery stables to provide boarding for visiting horses. To encourage commuters to settle in the area, the Rutherford Heights Association obtained a franchise to run horse-drawn cars over a single track. John Hollenbeck drove it from the Carlton Hill station over Riverside Avenue through Francisco Avenue to Santiago Avenue and southerly to Passaic Avenue, but the Francisco Horse-Car had an abrupt ending. One dark night, teenagers pushed the car down the Francisco Avenue hill, where (failing to make a turn) it hopped the track and landed in the woods, never to roll again. The teens lived to tell the tale. The photograph above was taken in 1907. (Above courtesy Virginia Marass.)

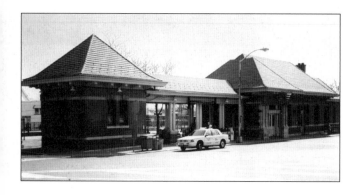

The Wolf tribe of the Lenni Lenape Indians settled the western banks of the Passaic (derived from *Pascak,* meaning "place where the river splits the rocks"). They crossed near Pierrepont Avenue, traveling to the Boiling Spring. Farmers sent their goods to Newark via the river *c.* 1717. The first steamboat to sail regularly on the Passaic (Passaic to Newark) was the *Olive Branch* in 1858. The *Hugh Bolton,* a side-wheeler built in 1865, made six trips daily, with sailing time depending upon the tides. The *Confidence,* built in 1860, took soldiers to Newark for enlistment in the Civil War. In the 1890s, the *Passaic Queen* left the Passaic Landing each morning for Newark, returning at 3:00 p.m. Washington Irving, visiting John Rutherfurd's estate on River Road, said that the Passaic River and its valley was one of the most beautiful spots he had ever seen. The older photograph dates from 1905. (Below courtesy Virginia Marass.)

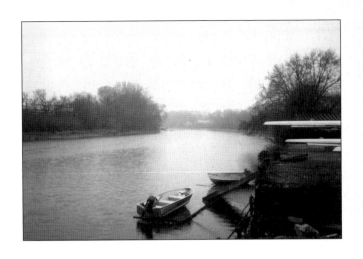

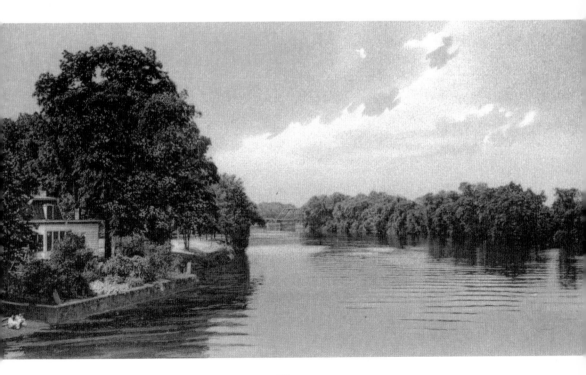

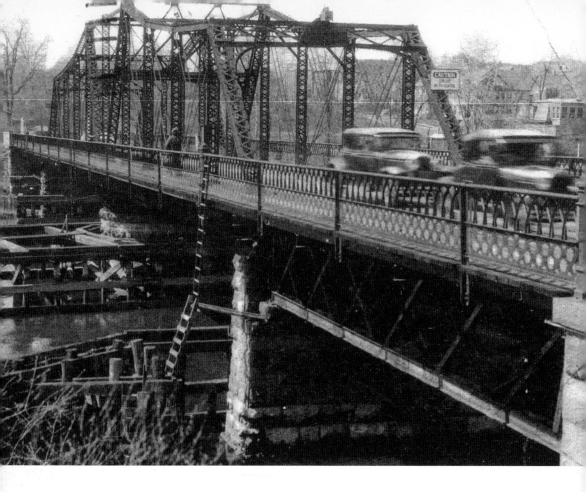

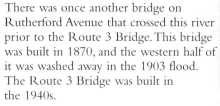

The Union Avenue Bridge crosses the Passaic River between Rutherford and Passaic. According to Work Projects Administration records, it was originally built in 1896 and was rebuilt in 1978. It is currently being reconstructed again.

There was once another bridge on Rutherford Avenue that crossed this river prior to the Route 3 Bridge. This bridge was built in 1870, and the western half of it was washed away in the 1903 flood. The Route 3 Bridge was built in the 1940s.

A stranger visiting a town for the first
time receives an impression of the
environment by looking at its buildings,
trees, schools, churches, and homes.
Ultimately, however, it is the people
working together that gives a town its
heart. They are the ones who created the
essence of the community called
Rutherford. It is through their sharing,
mutual support, respect, and sometimes
sacrifice that make the town a home.
Rutherford has had the benefit of people
who have raised generations of their
families in this community and has also
welcomed newcomers to benefit from all
that has been so carefully planned. This
tells the real tale of what it means to be a
part of a community that is not self-
seeking but supportive and appreciative
for all that each individual can contribute.

Chapter 7
THE PEOPLE

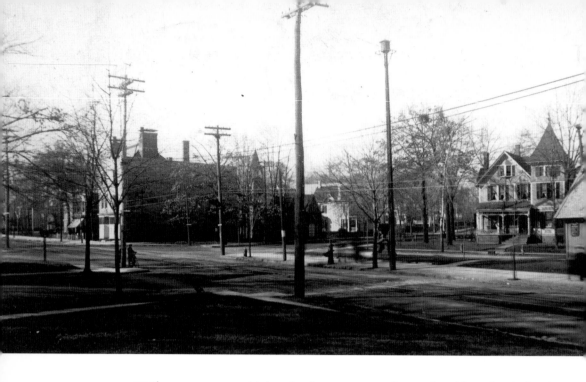

The monument at this location honors Rutherford's World War I heroes. It was designed by Edgar I. Williams, distinguished architect, Massachusetts Institute of Technology teacher, and brother to William Carlos Williams. Each part has a distinctive meaning. First, it represents a finger pointing to heaven. The lower base contains records of achievements. The bronze cover plate is an American eagle standing on fasces (reeds tied about an axe, symbolizing law and order). The tablet bears names of the 19 men who died, with a corresponding star. The reversed torches are symbols of lives passed from earth. Among the torches are laurel branches, indicating glory and honor. The oak leaves and acorns symbolize eternal life. The base ha[s] six eagles, the national symbol. Major engagements are listed on the shaft. At the top is a tripod (symbol of sacrifice) with [a] flaming light. The flame represents the light these Rutherford men, who died for our country, gave the world. The older photograph shows the sector before World War I.

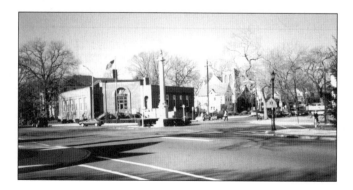

Three of the 19 young men who sacrificed their lives for our freedom and whose names are listed on the World War I monument's plaque are, from left to right, Thomas Everett, killed in action on September 29, 1918; Charles H. Schneider, killed in action on September 29, 1918; and Gerald E. Reynolds, killed in action on June 27, 1918. Rutherford was always honored and given due respect to its heroes. In town, there are numerous monuments, such as the World War II Monument, the Vietnam-Korea Monument, and the Sailors' Monument for the Spanish-American War, among others honoring these men and women. Rutherford was also home to Robert Leckie, a machine gunner and scout who received the Naval Commendation Medal with Combat V, the Purple Heart, and five battle stars. As a military historian, he has written many books, including *Helmet for My Pillow.*

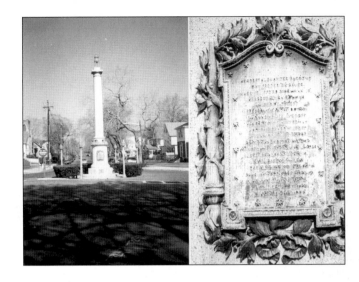

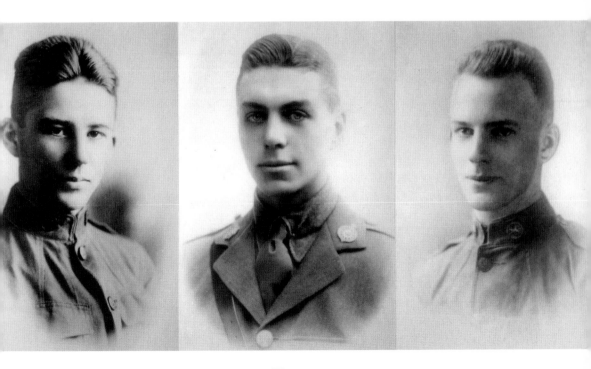

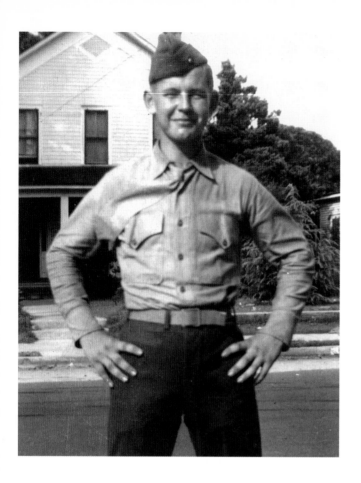

Iwo Jima is synonymous with our image of the soldiers raising the flag after capturing this island near Japan during World War II. On February 19, 1945, Sgt. Vernon B. Davies, a Rutherfordian, was a member of the U.S. Marine invasion forces that eventually conquered Iwo Jima. He was also involved with the invasion forces of the U.S. Marine Corps in capturing the islands of Saipan (June 1944) and Tinian (July 1944). Vernon enlisted in the U.S. Marine Corps in 1942 and was discharged in 1946. He reenlisted in the U.S. Marine Corps in 1950, joining the 1st Marine Division, and served in Korea until December 1953, when he was discharged. He is still residing in Rutherford and is the father of four children, nine grandchildren, and two great-grandchildren. He is an example of one of Rutherford's finest and is one of its heroes.

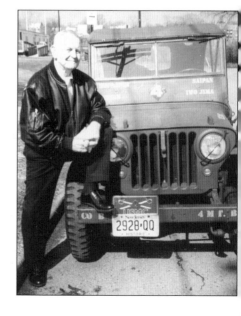

Rutherford is fortunate to have the Marion family as part of the community. The Marions have been actively involved in the town for many years, but it is probably not well known that John Calvin Marion is one of Rutherford's quiet heroes. He was first sergeant of the 81st Chemical Mortar Battalion and received the Bronze Star for meritorious achievement in connection with military operations against the enemy in Germany on March 22, 1945. When several of his men were killed and wounded by attacking enemy aircraft, he calmly and courageously took charge, evacuating casualties and encouraging his

comrades, thus preventing confusion and panic. His exemplary actions helped save many lives. Marion was also there on the night of June 5, 1944, and the morning of June 6, 1944. He was a part of the second wave of the invasion force at Normandy Beach, France (D-day). From D-Day on, he was in actual combat for well over 250 consecutive days.

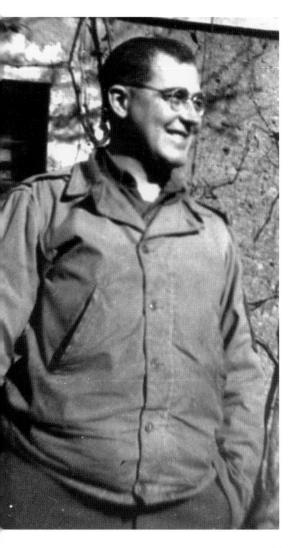

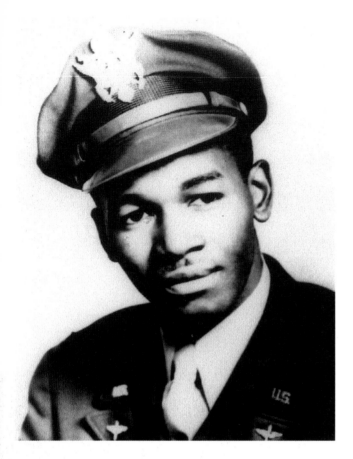

From 1943 to 1946, 1st Lt. Calvin J. Spann, USAAF, 15th Air Force, 332nd Fighter Group (P51), was a Tuskegee Airman of the 100th Squadron. He grew up in Rutherford and always wanted to be a pilot and ultimately trained in the P-47 (Thunderbolt) fighter aircraft for combat. He was among an elite group as the Tuskegee Airmen successfully escorted the B-17 bombers and the unarmed reconnaissance planes over central Germany during World War II. Calvin flew a P51D Mustang fighter aircraft on the historic mission from Ramatelli to Berlin, stretching the normal five-hour flying range to six hours. The 35-plane squadron received the Presidential Citation for this mission. Today, Spann is a member of the American Legion Post 453 in Rutherford and is a member of the Claude B. Govan Tri-State Chapter of the Tuskegee Airmen.

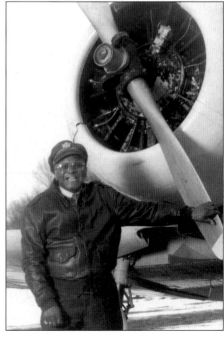

The Lincoln Park Cannon was dedicated on May 31, 1907, and has been a Rutherford landmark for more than 90 years. Former Rutherford Postmaster Mackay obtained this eight-inch Rodman gun. It was cast in Worcester, Massachusetts, measures 10 feet 4 inches, and weighs 8,593 pounds. The cement foundation was constructed by the Rutherford Cement Construction Company with materials furnished by Julius Jaeger. Originally, it was located at Martha's Vineyard and was moved to Fort Schuyler prior to the Civil War. Spanish-American War veterans and Colonel Hine, who was commander of the 5th Regiment, presented the cannon to Mayor Brinkerhoff during a ceremony attended by 9,000 people. The older photograph dates from 1907. (Below courtesy Virginia Marass.)

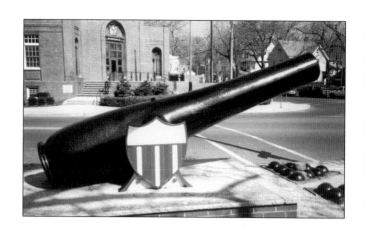

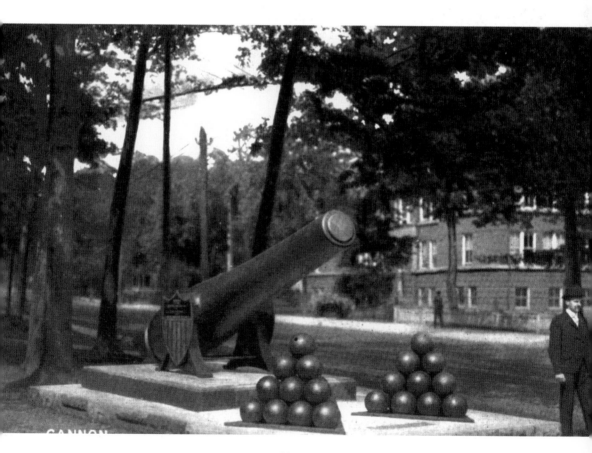

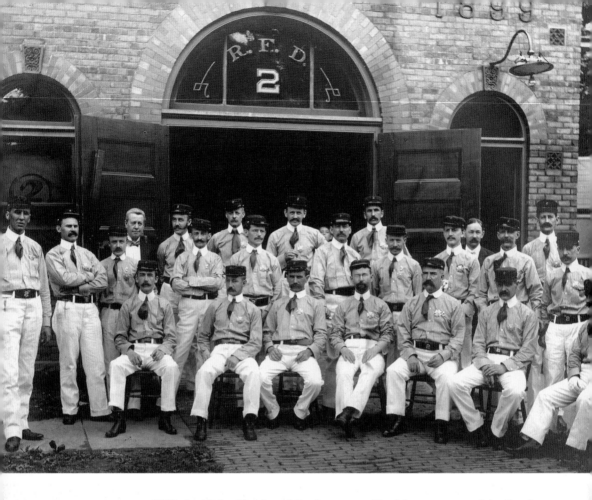

In 1876, the Union Truck and Bucket Company was organized as the first fire department. Company No. 2 was incorporated in 1886. Later, Company No. 2 became part of the fire department with the Union Truck and Bucket Company, which had already been fighting fires for 10 years. Fires were extinguished by bucket brigade then. The first firehouse for Company No. 2 was the old McMain building (near the Van Winkle building). The company then moved to quarters on West Passaic Avenue (near the present post office). In 1913, the company moved to 157 Park Avenue and is now located on Mortimer and West Pierrepont Avenues. The members of Company No. 2 have been known as the High Hatters. David Ivison, who lived in Iviswold, had an annual dinner for the firemen. Silk hats were donned for these occasions. An alarm sounded during one dinner, and the firemen responded while wearing their silk hats. Thus, they became the High Hatters.

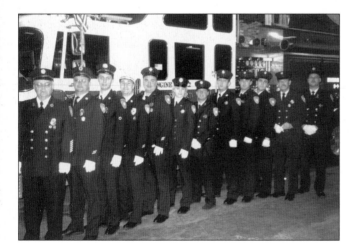

Company No. 3 came into being in 1890 as the West End Fire Engine and Hose Company. In March 1902, the Rutherford Avenue Bridge was threatened with destruction by the high-rising waters of the Passaic River but was saved by this company. Company No. 4 was originally the Rutherford Hose Company (organized in 1896), which later became known as Engine Company No. 4. In February 1914, Company No. 4 was the first in the area to receive a motor-driven engine (an American-LaFrance triple combination hose, chemical, rotary-gear 500-gallon pumper). The company is currently housed with Company No. 1. Rescue Company No. 5 was organized in 1948 and is housed on Union Avenue with Company No. 3. We are fortunate to be served by these Rutherford volunteers.

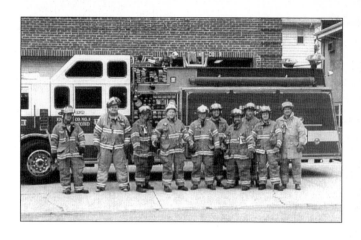

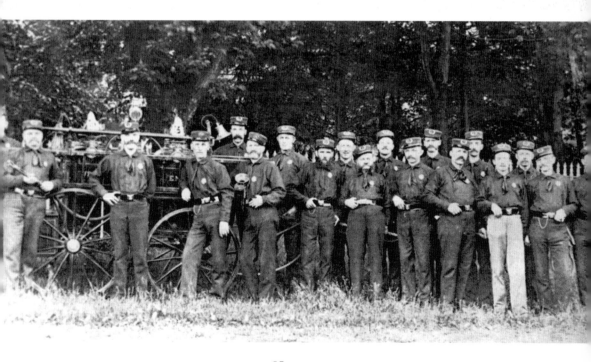

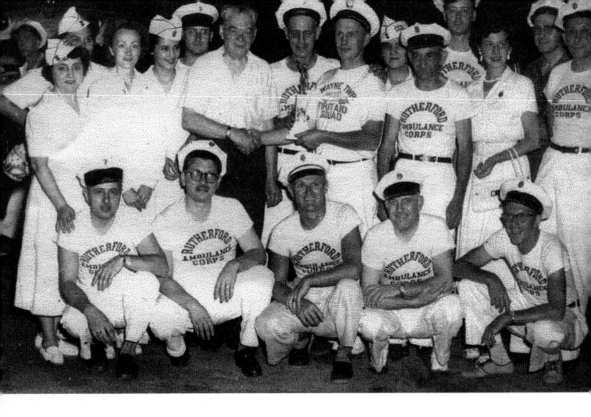

Although the actual organization of the Rutherford First Aid Ambulance Corps took place in 1949, the idea was brought before the community at the much earlier date of January 1942. At that time, the project was considered inappropriate. However, through the perseverance of Roland D. Ablemont and Thomas M. Crotzer, sufficient public interest was created to launch the fundraising campaign by 1949. In August 1950, the first ambulance (a Miller Cadillac) was purchased. On August 24, the ambulance made its first call. There are three groups that make up the Rutherford First Aid Ambulance Corps—the corps (associate members), the squad (active members), and the youth squad. All the members are volunteers trained b Red Cross first-aid instructors and continue to give many hours of their time to help Rutherford citizens.

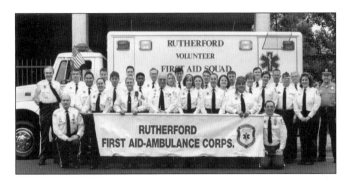

The Rutherford Police Department started in 1898, when the borough council authorized the purchase of uniforms and a bicycle for day patrolling. The first chief was George Holland (1898–1911). His staff was one sergeant and five patrolmen. At that time, a town ordinance gave the following charge to this department: "It shall be the duty of said Policemen to drive, take to and impound all swines, horses, goats, sheep and meat cattle running at large within the limits of the Borough." Their duties have greatly expanded since those days. Under the direction of Chief Steven J. Dienstedt, a 28-year veteran, the police force has 48 officers. Some current departments are the patrol division, criminal division, and traffic division. Service is provided around the clock with highly trained men and modern technological equipment, ready to respond immediately to any community need, having been organized to serve the citizens of Rutherford.

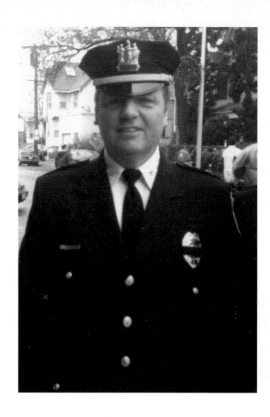

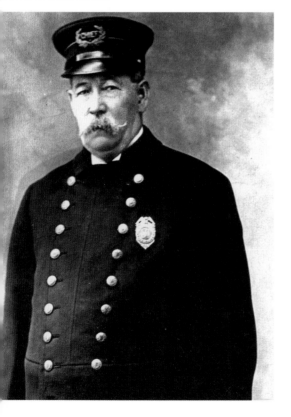

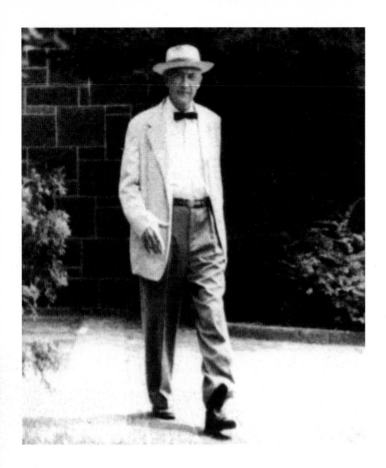

R utherford is a town with many cultural activities and home to many well-known authors, past and present. Of particular note is William Carlos Williams, seen walking out of the original library building designed by his brother, architect Edgar I. Williams. Williams (1883–1963) is regarded as one of the most important poets of the 20th century. His writings include 600 poems, 52 short stories, 4 novels, 4 plays, an opera libretto, a biography, an autobiography, an American history, and a collection of essays. He had an intense interest in locale, and Rutherford and its people were included in many of his works. Among his awards is the Pulitzer Prize in poetry. The present-day Rutherford Free Public Library was built in 1957, with the Dickinson Wing added in 1975. The library's permanent display on Williams includes his desk where he wrote many of his masterpieces.

There are myriad civic and social groups in Rutherford, and one group, called the Friends of the Williams Center, was formed in the early 1980s to give support to this cultural treasure, where music, dance, plays, and films are regularly performed in the concert hall, the children's Oscar theater, and the three cinemas. In the main concert hall, which is known for its perfect acoustics, there is seating for more than 800 people. This is the location of the magnificent Czechoslovakian crystal chandelier, which is the twin to the chandelier that was in the Roxy Theatre in New York City. (The Roxy chandelier disappeared.) It is a source of great pride and has been witness to such performers as Bert Parks,

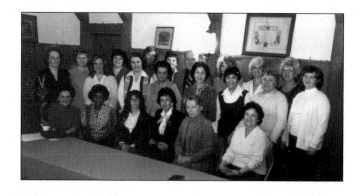

Douglas Fairbanks Sr., and the big bands of Harry James and the Dorsey Brothers. (Courtesy William Carlos Williams Center for the Performing Arts.)

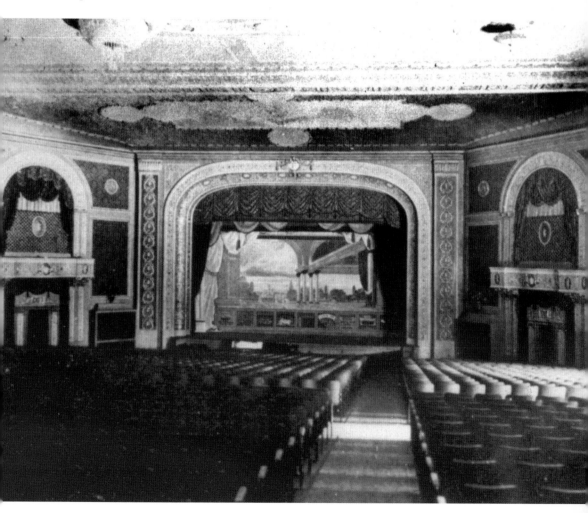

Music appreciation has been an integral part of Rutherford's cultural interests. Devoted fans of the Rutherford Community Band conceived the idea of a band shell, and dedication ceremonies were held on June 24, 1973. (Thomas Monroe founded the Rutherford Community Band in 1941.)

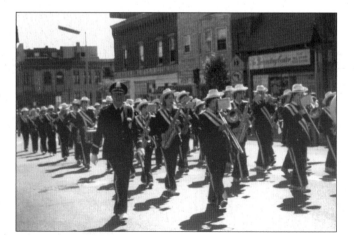

The band shell was named for William Hutzel, a former director of music in the Rutherford school system and of the Rutherford Community Band. Raymond Heller, who conducted the dedication concert in 1973, is the third man to direct the band in its history. (He also has taught instrumental music and was band director and coordinator of music for the Rutherford school system.) Lincoln Park on Thursday summer nights is filled with families experiencing the beautifully orchestrated free concerts. The older photograph is of a Lincoln Park audience at the dedication. The newer photograph shows Rutherford High School's marching band in one of many parades up Park Avenue.

ports have always played a major role in the activities of Rutherford children nd adults. Through the years, the focus of ports has necessarily changed, although me have remained the same throughout e years. One of the successes in reserving the history of a location is rough historic preservation, and the ereid Boat Club has brought rowing ck to the area by bringing the 1920s iver Road Boathouse back to its former ory. The Nereid rowers first hit the aters of the Passaic River in 1866. bday, this club is actively participating in gattas along the eastern seaboard (as ell as training new rowing crews) and is opeful of drawing participants from the early 17 rowing organizations that are ow operating in the greater New York netropolitan area for a Passaic River egatta in the near future.

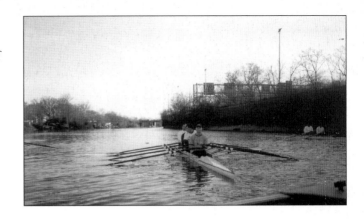

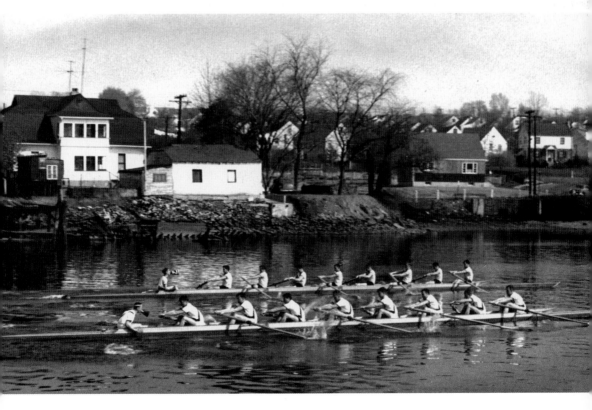

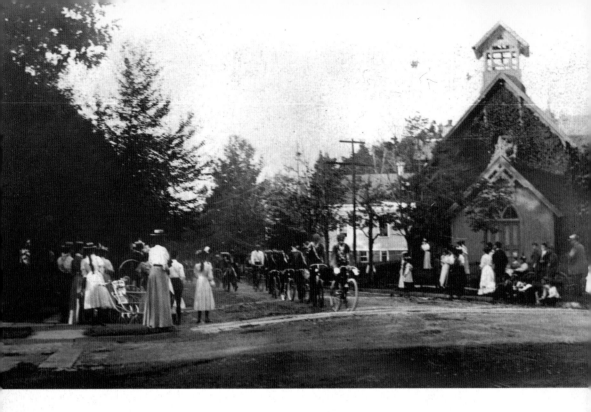

Today, many sports are included in the curriculum of our schools and in our recreational programs for all ages and abilities. Over time, preferences change in regard to the popularity of one sport over another. A good example was the Union Club (begun in 1885), which was the start of the Rutherford Wheelmen, who were devoted to bicycling, "a sport destined to become the most popular athletic diversion in the Borough." This club had a racetrack in town, fronting on Chestnut Street between Union and Ames Avenues. Today, football is one of Rutherford's most popular sports, with playoffs in colleges and additional teams in professional football extending the seasons well past New Year's Day. Avid young football hopefuls begin the sport at grade-school age in Rutherford's sports' program. The new photograph shows the 2001 Rutherford High School football team.

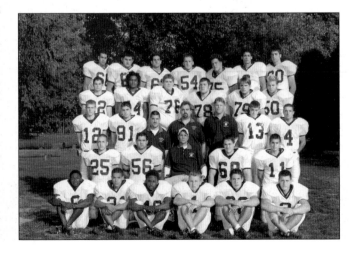

Sports in Rutherford in 1905 included the Star Athletic Club baseball team. Please note that William Carlos Williams, the celebrated Rutherford poet, played third base for the Star. In this photograph, Williams is kneeling at the right in the middle row. His brother Edgar appears at left in the front row. Women's sports, however, have become equal to men's sports in participation and competition. It begins at an early age, as can be seen in this photograph of a Rutherford girls' softball team. Many of these girls went up to play varsity softball for the Rutherford High School team.

The impetus for expansion of development in Rutherford began with the Rutherford Park Hotel's attraction as a resort area, with the entertainment provided by the Valley Brook Race Course. Today, the meadowlands adjacent to Rutherford and New York City are the location for entertainment, industry, and environmental studies for people from all over the country. There is still a racetrack—the Meadowlands Racetrack—as well as Giant Stadium, the Continental Arena, and the New Jersey Meadowlands Commission's Environment Center, with the advent of a golf course in the near future. The photograph of the meadowlands depicts the natural state of the land. The more recent photograph shows Rutherfordian Malvern Burroughs (Class of 1958), who helped to develop parts of the meadowlands. He is pictured with his horse Malabar Man winning Hambletonian at the Meadowlands Racetrack. This is just another example of the versatility of attractions that abound in the area, which provides inspiration, incentive, and serenity to the people of Rutherford. (Above courtesy Joseph Charleton Zenca.)

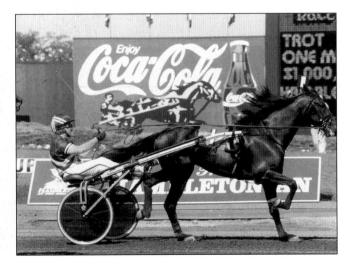

In 1981, a small gold-colored time capsule was lowered into the ground of Lincoln Park, where it will remain buried for 100 years. On this occasion, Mayor Barbara Chadwick read a message to the 2081 mayor of Rutherford. She read, "I pray while you read this that you are living in a world of peace and that Rutherford is a strong, vibrant community in our great United States." This is truly a gift of hope for future Rutherfordians. In the same context, former borough administrator Robert Gorman, a 17-year veteran to that position, has kept a plaque outside his office door: "Rutherford's location has contributed to its development as a suburban community with metropolitan opportunities." Location is not the only contributor to the development of Rutherford. With his philosophy—"in

local government, the common objective is to serve the community"—he has certainly followed this motto. He has helped point the way toward "a strong vibrant community in the future."

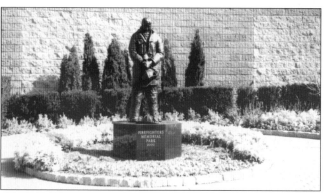

The torch pointing upward at the top of this tripod (which is the flaming light on top of the World War I monument) is to remind us of the sacrifices and help given to the world by Rutherford men and women. In that same spirit, we have a new memorial for our fallen firemen heroes who have sacrificed themselves for the protection of others. We will never forget.